THE NEW AMERICAN VILLAGE

CREATING THE NORTH AMERICAN LANDSCAPE

Gregory Conniff, Bonnie Loyd, Edward K. Muller, David Schuyler *Consulting Editors*

George F. Thompson *Series Founder and Director*

Published in cooperation with the Center for American Places, Santa Fe, New Mexico, and Harrisonburg, Virginia

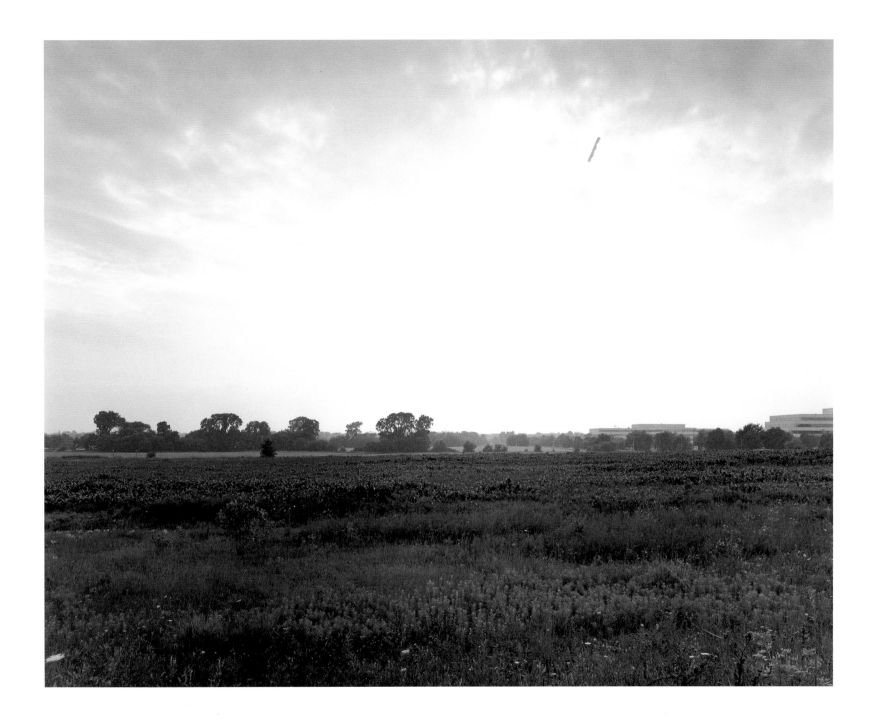

Bob Thall

THE NEW AMERICAN VILLAGE

THE JOHNS HOPKINS UNIVERSITY PRESS BALTIMORE AND LONDON

This book has been brought to publication with
the generous assistance of the Museum of
Contemporary Photography, Columbia College
Chicago, Illinois. *The New American Village*
is especially supported by U.S. Equities Realty,
Inc.

The Johns Hopkins University Press
2715 North Charles Street
Baltimore, Maryland 21218-4363
www.press.jhu.edu

Library of Congress Cataloging-in-Publication
Data will be found at the end of this book.
A catalog record for this book is available from
the British Library.

ISBN 0-8018-6157-8

ISBN 0-8018-6158-6 (pbk.)

frontispiece: Schaumburg, Illinois, 1992.

In memory of Harold Allen, wonderful photographer and teacher

CONTENTS

INTRODUCTION

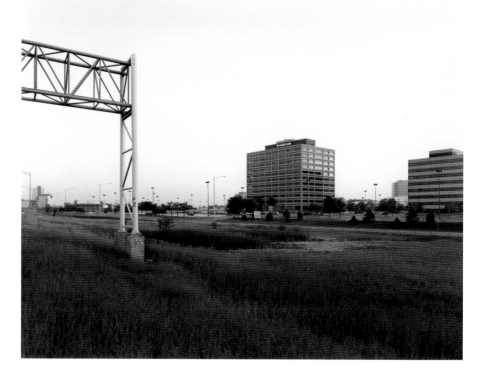

Route 53 and
Higgins Exit, Schaum-
burg, Illinois, 1996

I RARELY WENT to the new Chicago suburbs until I became interested in making photographs of them. I would occasionally drive through Rosemont on the interstate going to O'Hare or through Hoffman Estates on the tollroad to Wisconsin. I might go to an antique show in a hotel ballroom near the airport. I recall visiting Schaumburg only once, in 1989 or 1990, to see a close friend, Paul, with whom I had studied at the downtown Chicago branch of the University of Illinois. His business had prompted him to move from downtown to an apartment an hour or so to the northwest.

Paul had to give me detailed directions to his condo in the new "edge city": I-90 to 53, then to Higgins, then to Meacham, finally to a development called Lexington Green. The area where he lived, along Meacham Road near Higgins and Golf Roads, is the very epicenter of this book of photographs. It's an area I now know well, but then I had absolutely no idea where I was going. Inside Lexington Green I drove down a curving Williamsburg Lane past Buckingham Court, past Scarsdale Court, past Brookston and Sandhurst Courts, and finally to his place. I couldn't have found it at night.

Lexington Green comprises hundreds of identical two-story buildings. On the street side, the ground floor of each modest building consists of an entrance and four one-car garages. Like much of the housing in Schaumburg, the buildings look vaguely like single-family houses but are really small apartment buildings.[1] There are a few

1 Schaumburg is a fast-growing "edge city" suburb that combines large, glossy, high-rise office buildings, a huge indoor mall (Woodfield), modern industrial buildings, strip shopping, roadside franchise restaurants, townhouses, apartment blocks, and homes.

young trees at generous intervals. I was stunned. Nobody I knew lived out here. Artists, intellectuals—anyone with any culture or style—lived *in* Chicago. They never considered living anywhere else.[2] Paul had studied art and architecture. He was hip. What was he doing making the move to Schaumburg?

Inevitably, our conversation developed into an argument about my place in the city versus his new place in the suburbs. It's interesting that neither of us mentioned the most common objection to new suburban sprawl: the destruction of what was there before the developers arrived. John Szarkowski has written, in a foreword to Robert Adams's *The New West* (1976), that in our hearts we still believe that the only truly beautiful landscape is an unpeopled one. Adams, in that book and in others, expresses great sadness and anger about the damage done to landscapes that had seemed nearly perfect before the cancer of development and the arrival of new inhabitants.[3] I'm afraid that Paul and I felt none of this. We were city people, thoroughly bored by flat, featureless cornfields like the ones these condos had replaced. We weren't nostalgic for a farm life we had never known or understood. Nor were we sympathetic for the farmers (who, we imagined, had retired unexpectedly wealthy) or mournful for the original prairie, destroyed more than one hundred and fifty years ago.

Our discussion began with mundane concerns. I said that in the suburbs one has to rely on a car and drive everywhere. There is no pedestrian street life, and no areas mix work, shopping, and residential use, as do the livelier neighborhoods in the city. People are so similar within these huge new developments, I said, that the new suburbs have no diversity. These places have no old trees, used book stores, idiosyncratic restaurants, ethnic areas, or history. Suburban architecture aims at the lowest common denominator of middle-class taste; it is banal, standardized, and impermanent.

Paul said that the point is he *can* drive everywhere here. The city is impossibly congested but here in the suburbs the traffic is easier to handle. Once he gets where he's going he can find a parking space, a *free* space. He doesn't circle a block endlessly or get $50 parking tickets. The city is dingy, dirty, and the air smells bad. Downtown is expensive. If diversity means homeless people and gangs, I could keep it. And I could keep the crime, too, from the murders and arson to the puddles of shattered car-window glass in the gutter. How could I be critical of the view from his kitchen, a pond and lawn surrounded by identical buildings, when my own kitchen and porch faced the back of an apartment building?

The discussion took a somewhat personal and angry turn. I said his suburb is ticky-tacky, lacking in individualism or soul. Schaumburg is a generic place for generic,

2 Or at least this is the case until they have kids about to enter school. Then, with a certain ironic regret, they move to Evanston or Oak Park—old, leafy, progressive suburbs right on the Chicago border.

3 For more of Robert Adams's insights on landscapes, see: Robert Adams, *The New West: Lanscapes along the Colorado Front Range* (Boulder, Colo.: Colorado Associated University Press, 1974); Robert Adams, *From the Missouri West* (Millerton, N.Y.: Aperture, 1980); Robert Adams, *What We Bought: The New World Scenes from the Denver Metropolitan Area 1970–1974* (New York: Distributed Art Publishers, 1995).

unthinking people. Paul said that the city is out of control, a jungle. He attributed my preference for downtown to elitism and delusions of cultural superiority, pretensions that I paid for with a low quality of life. He paraphrased Robert Venturi's famous question: If the suburbs are so bad, why is there so much of them?

The substance of the debate Paul and I had that afternoon is not terribly enlightening. We traded fairly predictable and simplistic generalizations. Since that visit I've often noticed the emotional edge that suburbanites display when talking about "the city." On the other hand, people downtown, especially my colleagues and students, sneer at these new suburbs. Often, they seem shocked when I mention that I am photographing Schaumburg. "Schaumburg! Really? Why?" Some suspect I'm joking.

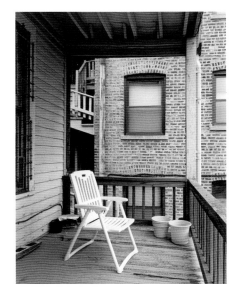

Back porch,
Chicago, 1997

I think we should expect this antagonism. After all, a sense of opposition, of challenge, between the core city and the new suburbs is common—even between old friends. The older suburbs such as Evanston and Oak Park have a symbiotic relationship with the central city. These new suburbs, however, intend to provide a complete, stark alternative to the central city. The design of the new "edge city" is a rebuke to many of the values of city life, and the growth of these new places poses a serious economic threat to the vitality of the central city they surround. Joel Garreau, an observer of urban change, wrote that:

Americans are creating the biggest change in a hundred years in how we build cities. Every single American city that *is* growing, is growing in the fashion of Los Angeles, with multiple urban cores.

These new hearths of our civilization—in which the majority of metropolitan Americans now work and around which we live—look not at all like our old downtowns. Buildings rarely rise shoulder to shoulder, as in Chicago's Loop. Instead, their broad, low outlines dot the landscape like mushrooms, separated by greensward and parking lots. Their office towers, frequently guarded by trees, gaze at one another from respectful distances through bands of glass that mirror the sun in blue or silver or green or gold, like antique drawings of "the city of the future."[4]

4 Joel Garreau, *Edge-City: Life on the New Frontier* (New York: Doubleday, 1991), 3.

Paul and I settled little that afternoon. Paul would have been surprised, however, had he known that several years later he would move back downtown, again prompted by changing patterns in his work. He now lives in Lincoln Park, one of the most desirable of Chicago's urban neighborhoods. He walks to the gym, to great bookstores, to any of forty or fifty ethnic restaurants within half a mile of his loft. He says he hasn't found a reason to drive out to Schaumburg for an entire year. I, in turn, would have been surprised had I known I would spend six years photographing in and around Schaumburg and come to regard it as the best example of the new "edge city" suburb in the Midwest and, perhaps, in the nation.

I HAD THREE REASONS to photograph the new suburbs. Early in 1991 I completed twenty years of photographing downtown Chicago. That group of photographs became *The Perfect City* (1994). Because I think of my work as an inclusive, long-term investigation of this great American city, I thought it would be good to examine another part of the metropolitan area: the new American village.

Second, I was attracted to what I initially perceived to be the extreme banality of a place such as Schaumburg. To my downtown frame of mind, these new suburbs seemed functional, undifferentiated, ubiquitous, prosaic. Whether we city folk like these places or not, we think we know what they are and, to some degree, we take them for granted. I agree with Frank Gohlke, who wrote that for the photographer of landscapes the highest goal is "to make the invisible visible, to see clearly and unsentimentally what has heretofore escaped our attention."[5] These new "edge cities" seemed to pose that type of challenge.

There was a third, more emotional reason for starting this project. While compiling the material that became *The Perfect City,* I looked at thousands of photographs I had made. I started with my earliest work and continued chronologically. It was a surprising exercise. I felt a wave of grief for old downtown Chicago, a landscape that had largely vanished during the building boom of the 1980s.

5 Frank Gohlke, *Measure of Emptiness: Grain Elevators in the American Landscape* (Baltimore: Johns Hopkins University Press, 1992), 21.

My photographs showed a sweeping transformation, from what felt like a nineteenth-century city to a new place with the character of a sunbelt city such as Houston.

For many years I walked the several square miles of downtown Chicago. I would usually photograph very early in the morning, on weekends, and after six o'clock on summer evenings. In the 1970s and early 1980s, the city was nearly empty at those times. I remember the quiet on those walks. At dawn on a Sunday morning, I felt as if downtown Chicago were my private city. It often seemed that certain streets and viewpoints were secrets only I knew. Each block had many small buildings built in different periods, providing clues to the city's history. The buildings showed layers of use, adaptation, and decay. If one looked closely, one could distinguish the work of individual craftsman and discern the window signs of businesses that had failed long ago. Small empty lots, alleys, and different building heights created a maze of space and light which changed throughout the day. I never had the feeling that I had seen everything.

During the mid- and late 1980s, developers tore down clusters of nineteenth-century buildings and replaced

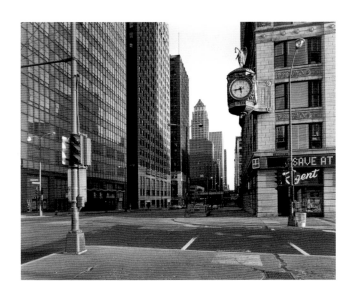

Wacker Drive and
Wabash Avenue,
Chicago, Illinois, 1977

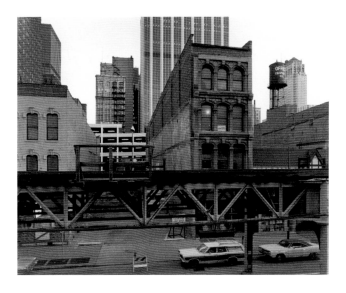

Lake Street near
Wells Street, Chicago,
Illinois, 1978

them with big new office buildings. These buildings have a larger "footprint," consolidating city blocks into one or two huge structures that block the light and simplify the urban space. The lobbies of these new buildings are sanitary and controlled. More people work downtown now. They start earlier, stay later, and work weekends. The city seems busier, and at the same time it seems less of a place for the pedestrian. Central Chicago remains a fascinating landscape, but it is harder to find peaceful moments, and when one does look closely at the city it seems that the rewards are less generous.

Looking at my old photographs, I became angry about the changes to downtown Chicago. In a vague, irrational way, I thought of these changes as an infection, the spread of a "corporate" and "suburban" style of landscape. Where had this blight come from? In the fall of 1991 I decided to look at the new suburbs, where I thought this new aesthetic was already distilled and triumphant.

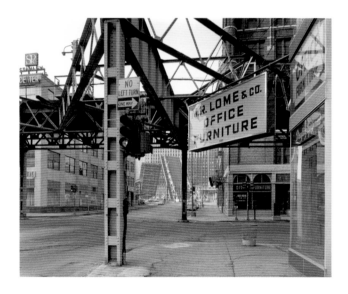

Lake and Franklin
Streets, Chicago, view
north, 1979

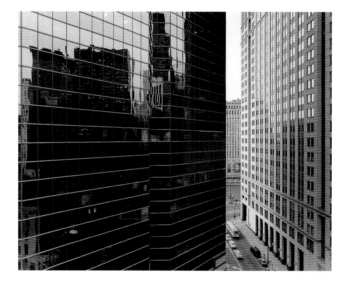

Lake and Franklin
Streets, Chicago, view
north, 1991

8

THE DRIVE TO THE SUBURBS from downtown Chicago is both fascinating and troubling. Like most American cities, Chicago radiated outward as it grew. One might expect, then, to find the oldest, most deteriorated neighborhoods close to the Loop and progressively newer areas as one travels outward. To an extent this is true, which suggests we can view the city as the cross-section of a tree trunk. However, cycles of economic rejuvenation and urban renewal, the routes of public transportation, the desirability of living near the lake, and, especially, racial and ethnic factors all complicate this comfortable metaphor. Chicago is a diverse, segmented, and largely segregated city. Some neighborhoods of spectacular brownstones are rotting, while other areas of small, undistinguished frame buildings are teeming with gentrification, investment, and stunning displays of wealth. The extreme range of the city's landscape can be shocking. While many areas of the city display that classic fastidiousness of the middle-class homeowner, much of Chicago's landscape is appalling—scenes of stagnation, decay, and ruin.

Meanwhile, the view from the twelfth-floor windows at Columbia College, where I teach in the photography department, opens up on glorious urban scenes. To the west and north is the Loop, to the northeast Michigan Avenue and the Art Institute of Chicago, and to the east are Grant Park and Lake Michigan. On class breaks and during my office hours I stare out the window, watching the city and lake under changing light and weather. I park my car in a nearby fringe of downtown. Those several blocks, with odd older buildings and parking lots soon to become big new developments, are reminiscent of the Chicago I photographed twenty years ago. My route northwest takes me through the slick western edge of the Loop and then across the Chicago River into an older loft area, now the fashionable gallery district known as River North. The view back toward the Loop can be lovely: In the right light, especially with a

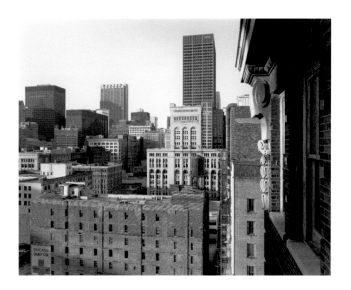

View northwest
from Columbia College
Chicago, 1997

slight haze, the high-rise office buildings blend into a dramatic cliff above the Chicago River.

The North Side was developed after the South and West Sides and, in comparison, can seem somewhat bland. The North Side lacks most of the elegant nineteenth-century architecture, but it also does not have the largest stretches of inner-city blight, the biggest public housing projects, or the unrepaired damage from the 1968 riots. Even so, there is much to look at and try to comprehend on the ride from downtown Chicago northwest to Schaumburg.

Between River North and gentrified Lincoln Park is an old and depressed area centered around Cabrini Green, the notorious Chicago Housing Authority development. In the early 1970s I photographed many of the old streets in this area, most of which the city bulldozed a few years later. The area still has a great deal of open space. Some townhouse developments have been built on the safer edges. Cabrini Green itself is a collection of seventeen grim apartment buildings, in which life is violent and dehumanizing, even by the standards of Chicago's public housing. Past these high-rise public housing build-

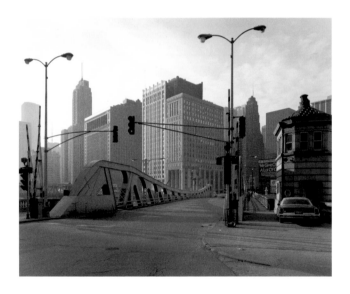

The Chicago River at
Franklin Street, Chicago,
1981

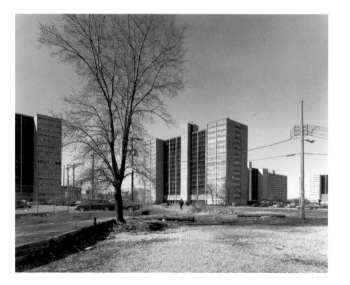

Cabrini Green, Chicago,
1997

ings parades a constant stream of BMWs, Infinitis, and Mercedes as the owners travel from downtown and River North to their very expensive homes in Lincoln Park and DePaul. I once stopped at a red light on Clybourn Avenue in the middle of Cabrini Green and observed the people walking across glance at the eighty-thousand-dollar Mercedes that had stopped next to me. It was difficult to read their expression.

Up Halsted Street into Lincoln Park, I pass by many restaurants, bars, coffee places, an Internet cafe, bagel bakeries, unique shops, and great used book stores. Generally, many people are on the sidewalks: yuppies, artists and intellectuals, students from nearby DePaul University. I drive past the slick loft that Paul moved into after having left the suburbs. At intervals in the city are nodes of commercial development from the 1930s. These areas, such as Lincoln-Belmont-Ashland, Broadway in Uptown to the northeast, or "Six Corners" further northwest, had clothing, shoe, furniture, and department stores. Upstairs were the neighborhood doctors and dentists. Architectural historian Robert Bruegmann suggests that these outlying shopping centers in the city, most of which lost their vitality many years ago, were the precursors of the new regional shopping nodes of the suburbs.[6] Today, some of the old department stores are being gutted and turned into lofts for young professionals. The terra cotta building on Lincoln Avenue that used to house a Goldblatt's Department Store is the most recent conver-

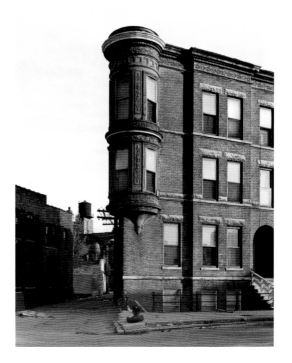

Blackhawk Street near Halsted Street, Chicago, 1973

6 For this reason, and others, Robert Bruegmann does not find suburban sprawl alarming. Robert Bruegmann, "Schaumburg, Oakbrook, Rosemont and the Recentering of the Chicago Metropolitan Area," in *Chicago Architecture and Design: 1923-1993*, edited by John Zukowsky (Chicago and Munich: Art Institute of Chicago and Prestel/Velag, 1993).

sion. About two miles northwest of Lincoln Park is my neighborhood, sometimes called North Center or St. Ben's. This is the current outer edge of gentrification.

I drive past my neighborhood into the great Northwest Side, the classic Chicago blue-collar neighborhood. This largely residential area extends for miles. There is little gentrification or noticeable clusters of restoration here. Yet, there isn't the type of disinvestment and deterioration that one sees closer to downtown. Yuppies find this part of town uninteresting and unfashionable; these are the neighborhoods where white police officers and fire fighters live. I usually merge here onto the Kennedy Expressway. The housing on either side of the road becomes newer and newer. Eventually, near O'Hare International Airport, the city rather seamlessly blends with the suburbs. Some of the suburbs in this area are older, traditional places, but this is also where the new American village begins.

A cluster of high-rise buildings sits near the Chicago-Rosemont border. The highway interchange that splits traffic onto various toll roads and into the airport creates a huge bowl of space, surrounded by office and hotel

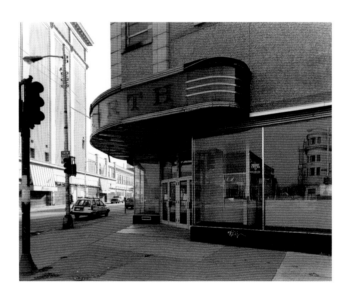

Lincoln Avenue at School
Street, Chicago, 1995

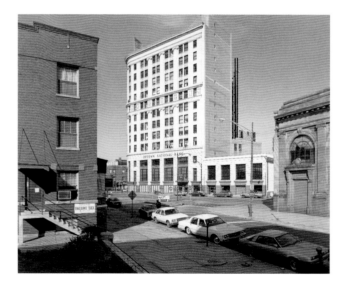

Broadway, Uptown,
Chicago, 1982 (for the
Canadian Centre for
Architecture, Montreal)

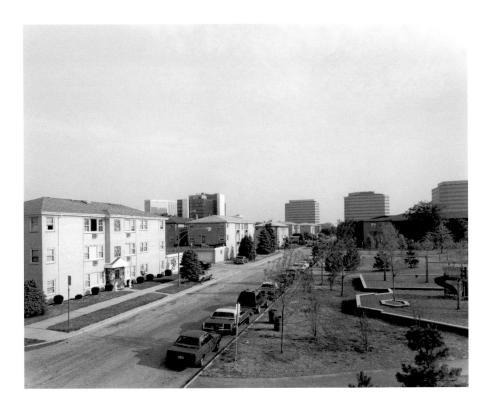

Near O'Hare
International Airport,
Chicago, 1991

towers. This short stretch of road is rather spectacular. It's a dynamic visual experience that is difficult to capture in a photograph. Sometimes I stop to photograph in Rosemont, but usually I continue on I-90, past the edge of O'Hare toward Schaumburg. The exit at Route 53 gives a wonderful view: a pure scene of traffic on the ramps silhouetted against the office buildings and the sky.

In the Chicago area these new "fringe city" suburbs cluster near O'Hare and along some of the major interstate highways, particularly I-90, I-88, and I-355. Harbors,

rivers, and railroads originally generated the growth of urban centers. The intersection of busy interstate highways and, more importantly, the intersection of highways and major airports such as O'Hare now spawn new economic hubs and their residential areas. These new villages include corporate headquarters, technologically advanced businesses, distribution centers, and new standardized retail operations. Few of these businesses are local, unique enterprises. Rather, national corporations and franchise businesses, which show little architectural accommoda-

Schaumburg,
Illinois, 1993

South Barrington,
Illinois, 1995

tion to their specific location, dominate the landscape. These towns still include residential enclaves, but such enclaves are not often made up of the single-family detached homes typical of the post–World War II suburb. Much of the population, single people and young couples without children, lives in architecturally complicated row houses or in apartment buildings. Many of the apartment complexes have a pool and clubhouse, and new row houses feature amenities such as two-story living rooms and fan-shaped windows. Unlike in a traditional suburb, most of the people living in these areas don't commute to work downtown. The population of this new suburb *increases* at nine o'clock on Monday morning.

ANY ATTEMPT TO DESCRIBE A PLACE is a complicated balancing act for a photographer. First are concerns of fairness, objectivity, and documentary completeness. If one goes too far in the direction of documentation, however, the project becomes an assemblage of raw visual facts, the photographs mere illustrations in a catalog of items. Doing this type of work, one tries to create photographs that have integrity, beauty, and resonance as new objects, not just as records. Too much concern with form, though, risks losing the photographs' connection with the real world. Furthermore, one wants to communicate personal insights. This type of photography, like all art, is most engaging as a statement of opinion, bias, and belief. On the other hand, the photographer must be concerned that too much of his or her opinion does not cause the

Hoffman Estates,
1995

Itasca, Wheaton, Naperville, Aurora, Downers Grove,
Lombard, Oakbrook, Elk Grove Village, Arlington Heights,
Rolling Meadows, Hoffman Estates, South Barrington,
Bartlett, Roselle, the northwest edge of Chicago, and
other places. I paid little attention to municipal bound-
aries. These towns now form an uninterrupted metropoli-
tan area, and city borders are often unclear.

Providing a balanced view of any particular suburb
didn't concern me much. (Some of these villages do have
older, traditional, small-town cores, which I ignored.)
Instead, I tried to photograph the landscape of the new
type of suburb, the suburb that is a miniature city, a calcu-
lated alternative to the "real" metropolis and all of its
problems and trappings.

Many of my early days photographing the suburban
landscape ended in the basement of elegant high-rise
buildings, facing irritated and puzzled directors of corpo-
rate security. I soon realized that rarely is there a clearly
marked public space in these suburbs. Where do the back-
yards end and the public parks begin? Is a small, residen-
tial street public property, or is it the restricted driveway
of a private development? Ponds, parking lots, and side-
walks within shopping malls can look public, but they are
usually private properties. There are virtually no places in
the edge cities where a stranger has the right to walk
around with a camera on his or her shoulder or set up a
tripod. Jane Jacobs, in her still important book *The Death*

viewer to suspect that the photographs are unreliable,
that the photographer has stacked the deck.

These contradictory concerns, even the very terms *art*
and *documentary*, can drive a photographer to distraction.
Over many years, I've learned to fight this confusion and
get down to productive work by thinking of my job in a
simple, reductive way. I select a place and spend as much
time as possible there, even years, walking and driving
and looking for photographs. Initially it's a haphazard
way to come to know an area, but slowly the place reveals
itself and I begin to understand what I find most interest-
ing and important. I then try to make pictures, straight-
forward and factual-looking photographs that distill and
exaggerate those aspects.

Schaumburg and Rosemont were the most obvious
starting points for this project. I later photographed in

and Life of Great American Cities (1961), argues that providing for the stranger on the street and a clear delineation of public and private space are essential ingredients for the vitality of city life. I discovered that the new American villages, reacting against the threat of inner-city crime, have opted for total control. I learned to call ahead, network, and check in with the security guards before I started to work.

I now have a more complicated understanding of the new suburbs than when I first argued about them with my friend Paul. As I expected, some appallingly flimsy

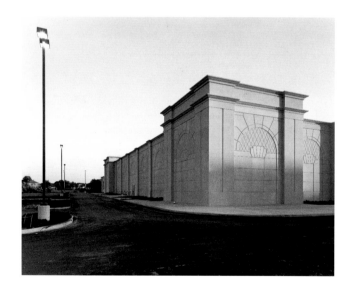

New Department Store,
Oakbrook, Illinois, 1996

new townhouses are being built. These new frame buildings use plywood only at the corners, while other outside walls consist merely of thin siding, insulation, and wallboard. One can usually see where workers have accidentally knocked holes right through the wall. Commercial buildings in strip malls display caricatures of classical pediments and column capitals sculpted in expanded polystyrene. These foam architectural forms are coated with fiberglass mesh and then sealed with a layer of material called DryVit. Designers place these fragile architectural gestures high on buildings, safe from the potential damage of shopping carts.[7]

Paul was right, though, when he argued that there is some good, significant new architecture in these suburbs. I photographed several new corporate headquarters built with great style, architectural integrity, and a real concern for the quality of life of the inhabitants. I was also impressed by a new type of distribution center. Designed to provide a huge interior, some of these buildings have one undivided main space with as much as 500,000 square feet. Standing inside one of these new "big boxes," regarding so much contained space, is a grand and fundamental architectural experience. Before one laments the sterility of these new workplaces, one should compare them to traditional factories, mills, and foundries.

I was wrong to assume that these new American villages would not include minorities. The suburbs in this

7 I have an old friend, Ken, who worked as an architect outside Los Angeles. For several years he specialized in designing windowless concrete industrial buildings in suburban areas similar to those in this book. He's done a lot of thinking about the best way to decorate plain exterior walls: vinyl paint, inlaid brick, incised designs, or decorative chips of aggregate in the concrete. His choice, finally, was to coat the solid walls in mirrored glass. Recently, Ken gave up architecture and opened a coffeehouse in the historic area of Charleston, South Carolina.

book are more socially diverse than I expected. Some African Americans and recent immigrants from the Pacific Rim do call this area home. Compared to the central city, however, these suburbs are remarkably homogenous: mostly white, young, and middle class. Often, it was strange and disturbing to leave the social variety of Chicago and drive to such a nearby place where one finds few old people, few people of color, few poor or homeless people, and few new immigrants. The difference is striking. It's difficult not to see these new places as symptoms of, and contributors to, the increasing social polarization in the United States.

I now understand how Paul could have found the clean, unbroken newness of these suburbs to be a relief from the older city. To be sure, the central city is full of decay, dinginess, failure, and struggle. Each empty storefront is the husk of some small business tragedy. The names on the tops of nineteenth-century buildings recall women and men dead for a hundred years. Glorious old movie theaters are now empty or used as evangelical churches and bowling alleys. Once famous nightclubs have been converted to convenience stores. Much of the city's landscape now seems to be disappearing like dead leaves in the winter. Fresh suburbs provide an escape from that sort of melancholy. And these places *are* safer. I've always been very cautious as I photograph in downtown Chicago, trying to be aware of who is around me at every moment. In these suburbs, I relax. I can keep my head

under the dark cloth and concentrate on the ground glass's image without nervousness.

Out on the edge of the metropolitan area I found typical Illinois farmland transformed. Where once grew huge, flat fields of corn there are now hundreds of gentle depressions filled with water. Mainly for flood control, developers have created innumerable small lakes and ponds. One can see great blue herons wading in the center of industrial parks, and geese and ducks are everywhere. Flocks of geese have flown so close over me as I timed my exposures at dusk that I could feel the beat of

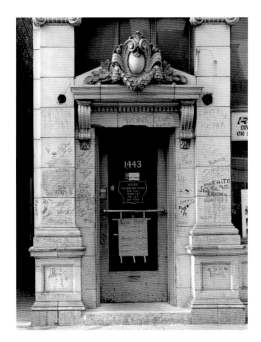

Eighteenth Street, Chicago, Illinois, 1974

their wings. The new landscape of these suburbs is, of course, far from a pristine, natural prairie, but the new American village may be an ecological improvement over the single-crop farms they replace.

Although Paul has returned to the "real city," I think that he and I would still disagree about the emotional quality of these suburban landscapes. On hot and cloudless summer days I found photographing difficult. The main streets are four-lane roads busy with fast-moving traffic, and I was often swept along and had little chance to pull over and contemplate a scene. On those days, I would drive a hundred miles or more in huge, looping circles. I would pass the same franchise businesses on Golf Road, Roselle Road, Butterfield Road, and Route 59. Everything, for hundreds of square miles, looked much the same to me. The recurring ponds and geese didn't help much. The lack of trees, the cheap standardized construction, the ceaseless flow of cars, the acres of black-top and concrete, and the unwalkable distances across open, flat land would leave me with an overwhelming and chilling sense of desolation.

The expensive corporate edifices may age well, but what about the rest of these suburbs, especially the flimsy domestic and commercial architecture? What will these places be like in thirty or even twenty years? Will vast expanses of homes all start disintegrating at once? Is it possible that these suburbs will become huge, low-density slums?

Jane Jacobs suggests several requirements for the "exuberant diversity" that can create a thriving, self-renewing city neighborhood or district. She calls for areas that have more than one primary use, encouraging people to be outside at different times throughout the day. The ideal neighborhood should have a good mix of buildings of different sizes, conditions, and ages, which can accommodate a wide range of users. Jacobs also argues for neighborhoods of high population density and for many short blocks with lots of intersections.

The neighborhood where Paul now lives is a good example of a district that fulfills all of Jane Jacobs's requirements. Lincoln Park has a good mix of business, commercial, and residential buildings. Lincoln Avenue and Clark Street slice through the neighborhood at odd angles, generating many interesting corners and short blocks. The buildings range from slightly decrepit old storefronts with apartments up above to million-dollar townhouses. The mix of uses and the area's high density ensure that many pedestrians are on the street throughout the day and into the evening. It is possibly the most desirable neighborhood in the city. Real estate values are soaring.[8]

A neighborhood that goes against all of Jane Jacobs's prescriptions is further north, on the border of Chicago and Evanston. This district, the north part of Rogers Park, is a homogenous area of brick courtyard buildings. The apartments are all one- and two-bedroom flats, built at the same time during the 1920s. The area, bordered by a

8 My friend Jocelyn lives in a ramshackle frame five-apartment building in Lincoln Park. She'll have to move soon. The property was just sold for $360,000 to a buyer who simply wanted the 25' X 125' lot. The existing building will be torn down to construct new condominium apartments. Recently, newly remodeled buildings in Lincoln Park have also been torn down to combine two lots into enough space for multimillion-dollar homes.

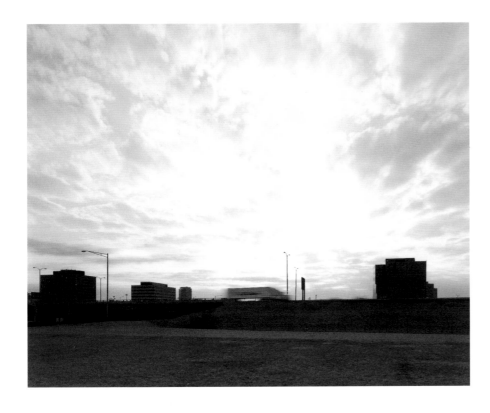

Route 53 at I-90,
Schaumberg, Illinois,
1993

9 It's ironic that as sub-
urban shopping centers
build sidewalks and
mix coffee shops with
bookstores, encouraging
walking pedestrians,
the city of Chicago is
allowing many
commercial streets to be
converted to areas
designed around parking
lots. Small storefront
buildings on streets such
as Irving Park Road
and Clybourn Avenue
have been torn
down, replaced by
franchise super-stores
and suburban-style
stripmalls.

subway-car facility and Calvary Cemetery, has some very long blocks and dead-end streets, discouraging pedestrian rambles. In the last twenty years, this entire area has become old and worn-down. From its inception the district lacked the diversity of buildings, uses, and population that could have sustained it through cycles of decay and regeneration. It has become one of the most dangerous and troubled areas on the North Side of Chicago.

The new suburbs in this book lack the kind of energetic diversity and density that Lincoln Park and other urban areas display. A few shopping centers have tried to recreate a small-town, "Main Street" sort of atmosphere, but these are small, isolated simulations of the city.[9] Is diversity necessary for regeneration in the suburbs, as it appears to be in the city? If so, the future of these landscapes is not hopeful.

We will have to wait to see how the new suburbs age. Meanwhile, perhaps the most intriguing aspect of the new American village is its apparent success. In the city, the landscape is a mosaic of contradictory intentions,

diverse needs, inescapable consequences, and seemingly out-of-control processes. City living is a matter of compromise and integration. What one sees in the central-city landscape is partly the intended design, but it is mostly an accommodation to existing circumstances, the passage of time, economic constraints, political antagonisms, infrastructure decay, and the changing social environment. These new suburbs started with a clean slate, a clear purpose, and political and financial power. It may be that the developers, residents, and corporate owners of the new American village have gotten exactly what they want. Like all such rare complete triumphs, the victors are left to consider not the limits of their effort but the quality of their original vision.

PLATES

The Corporate Landscape

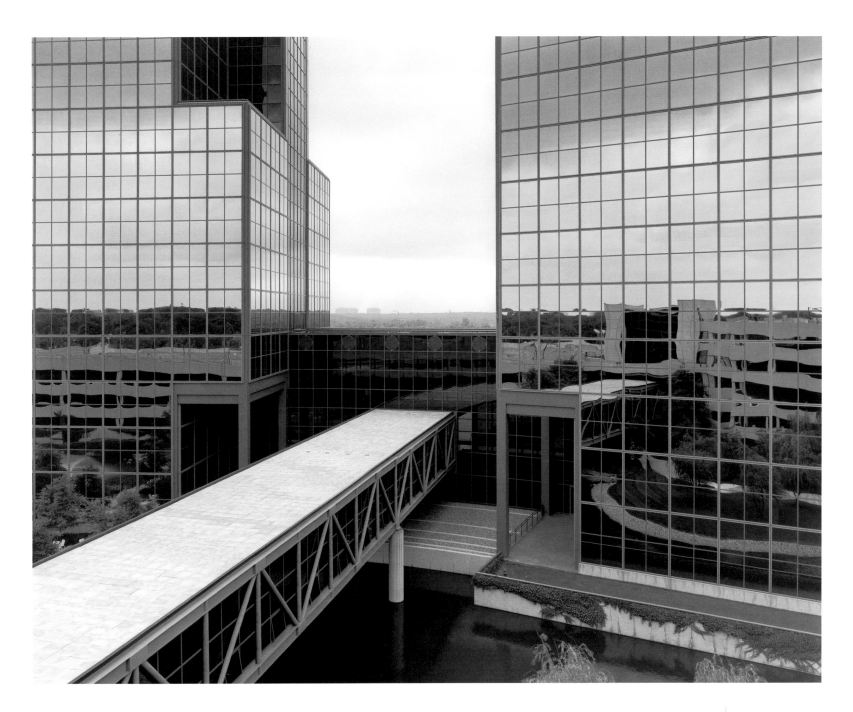

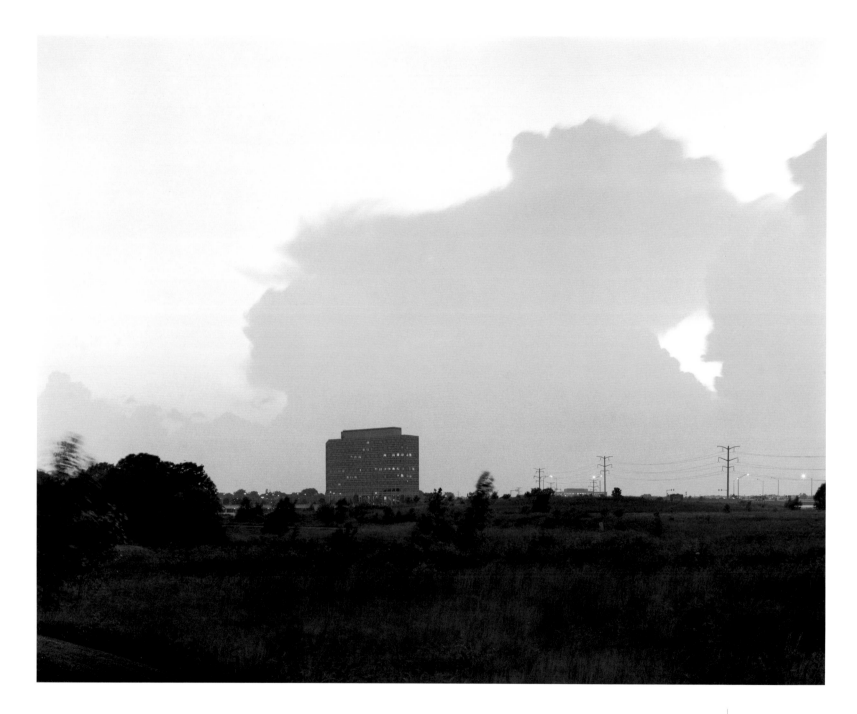

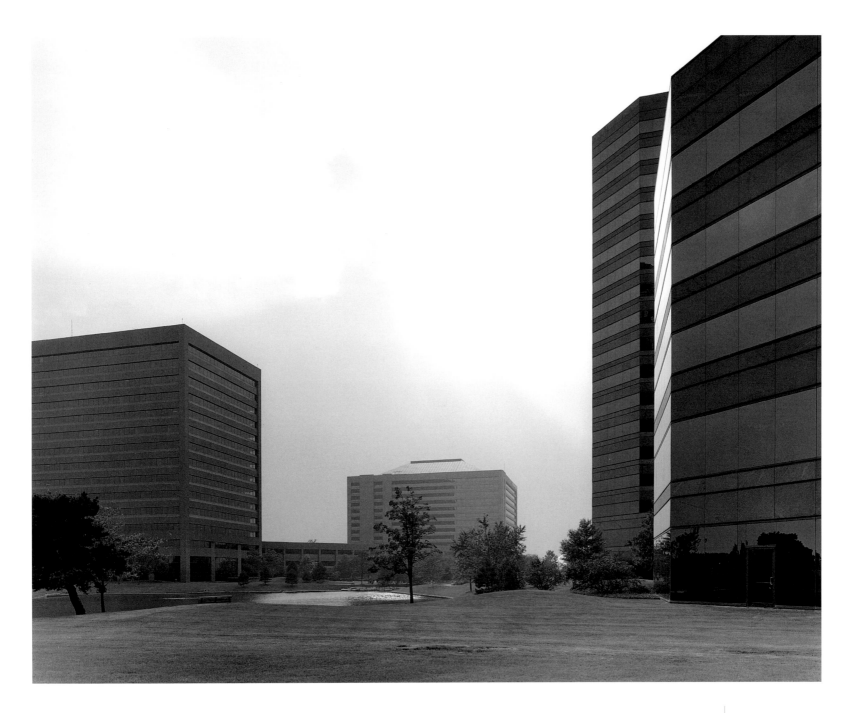

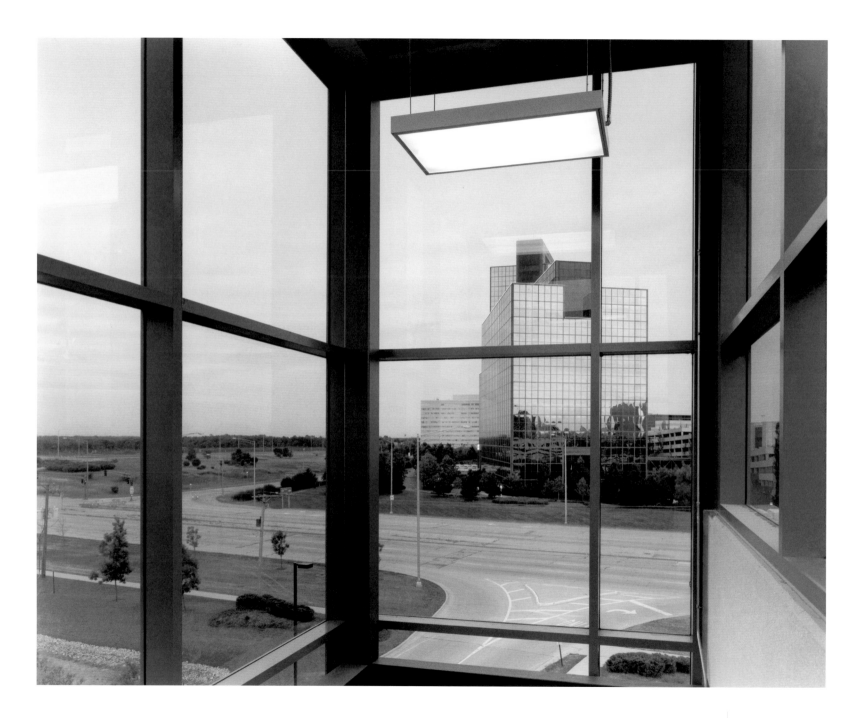

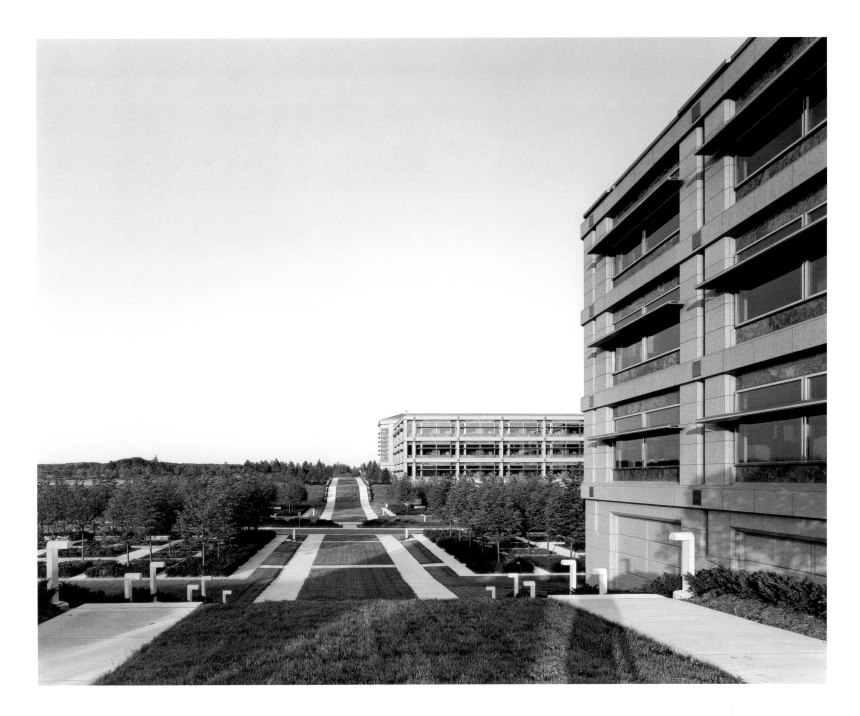

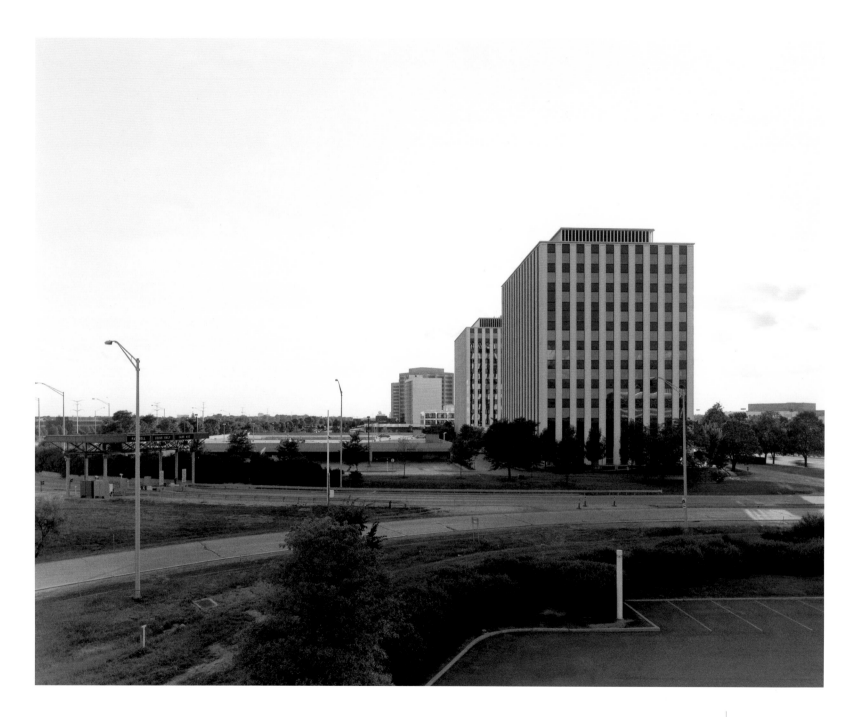

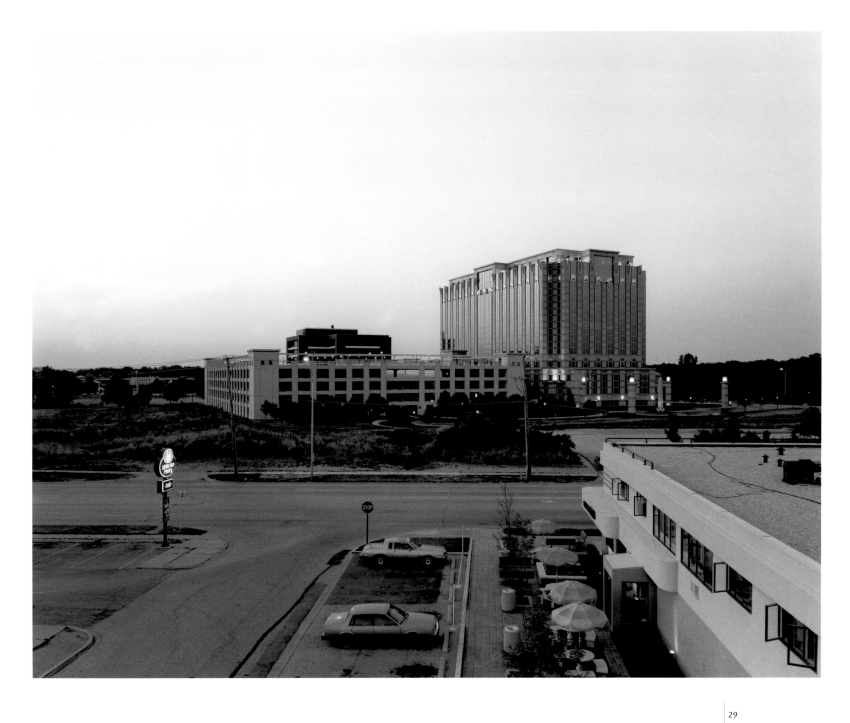

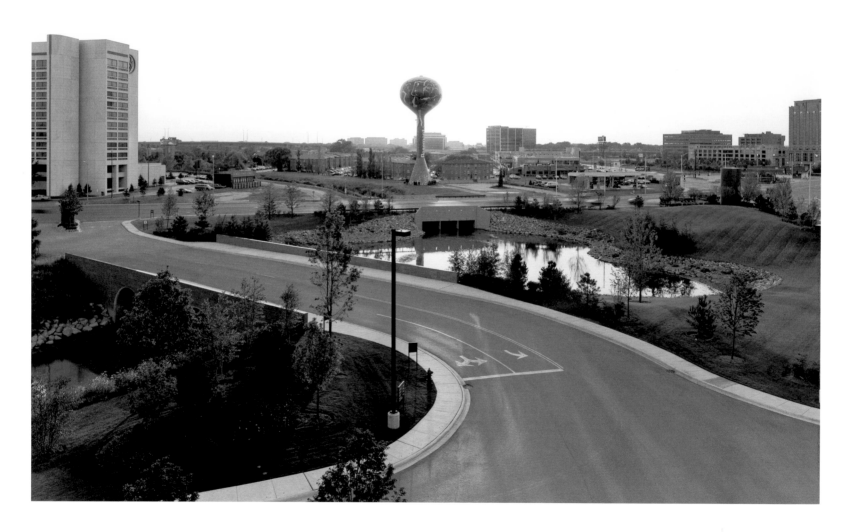

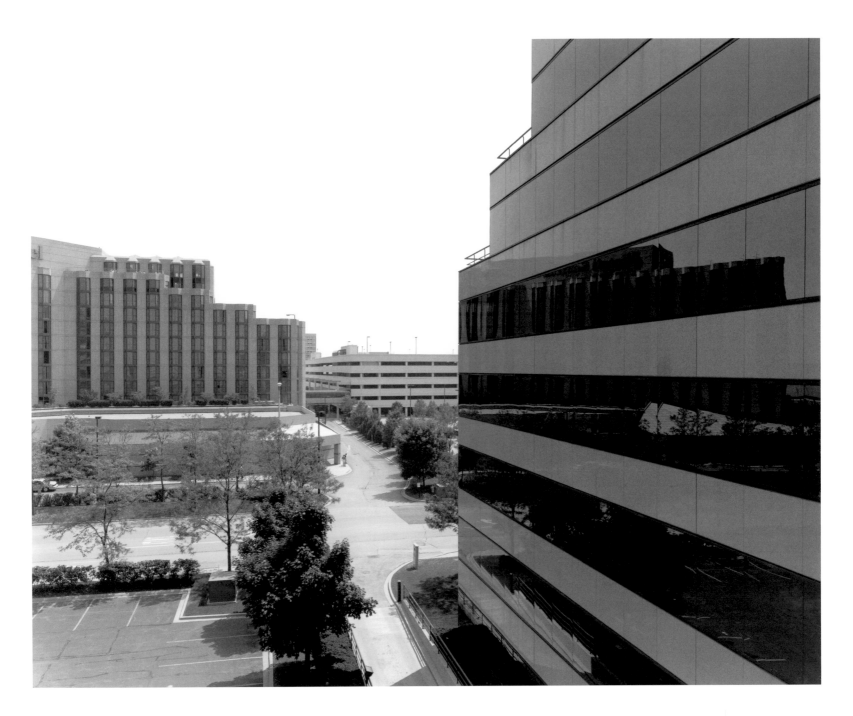

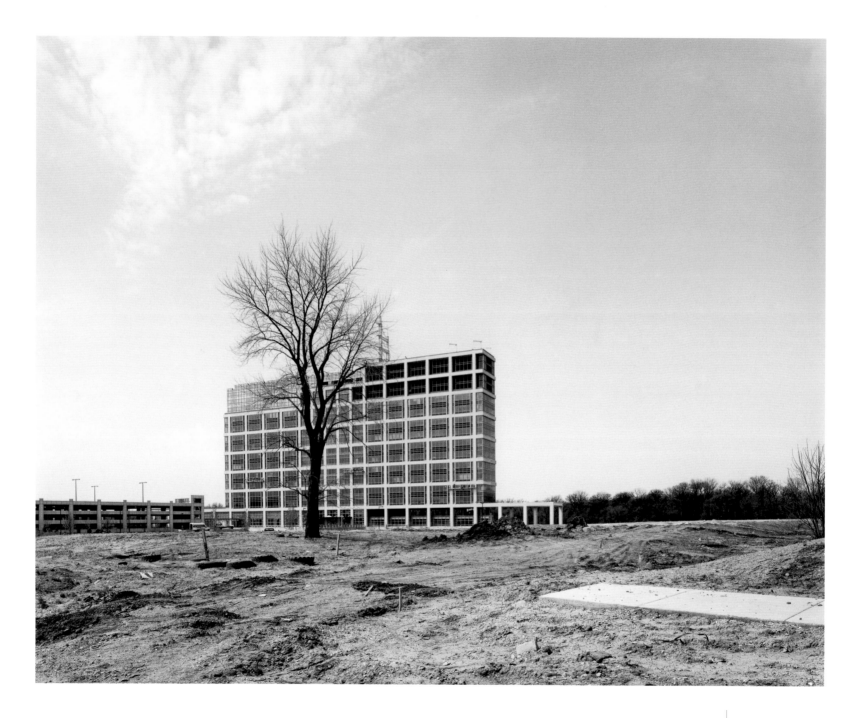

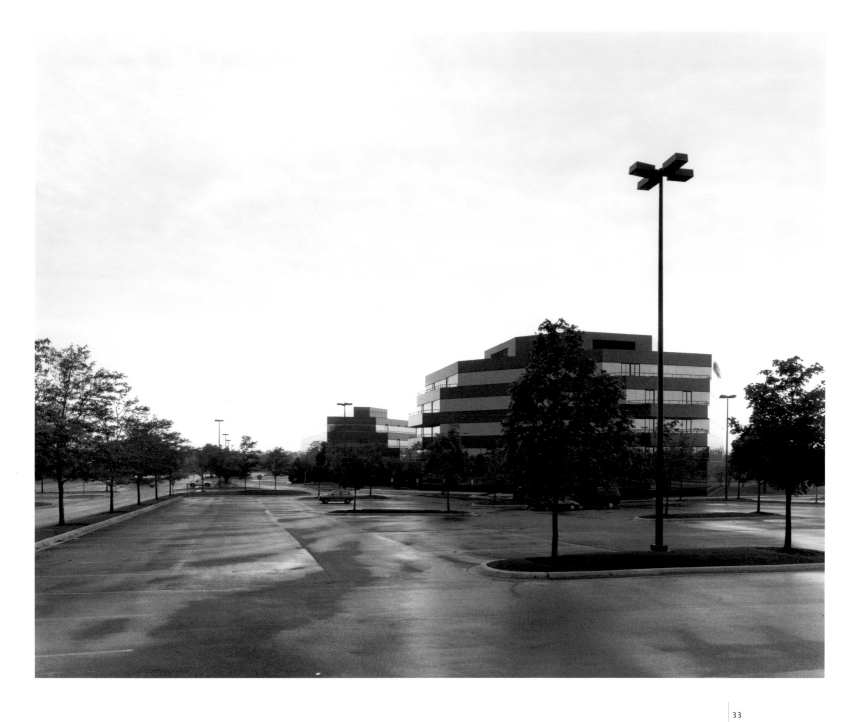

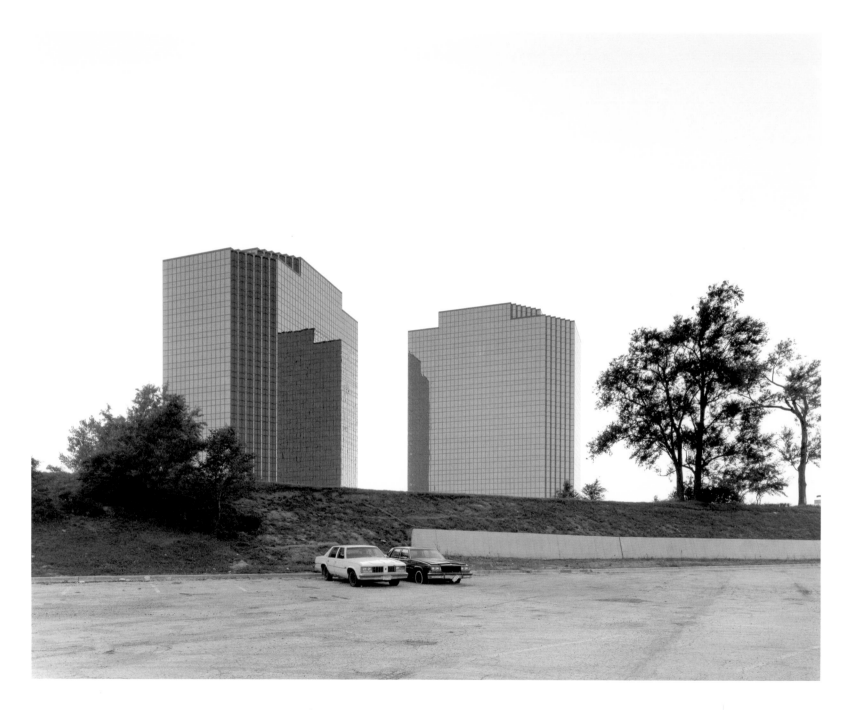

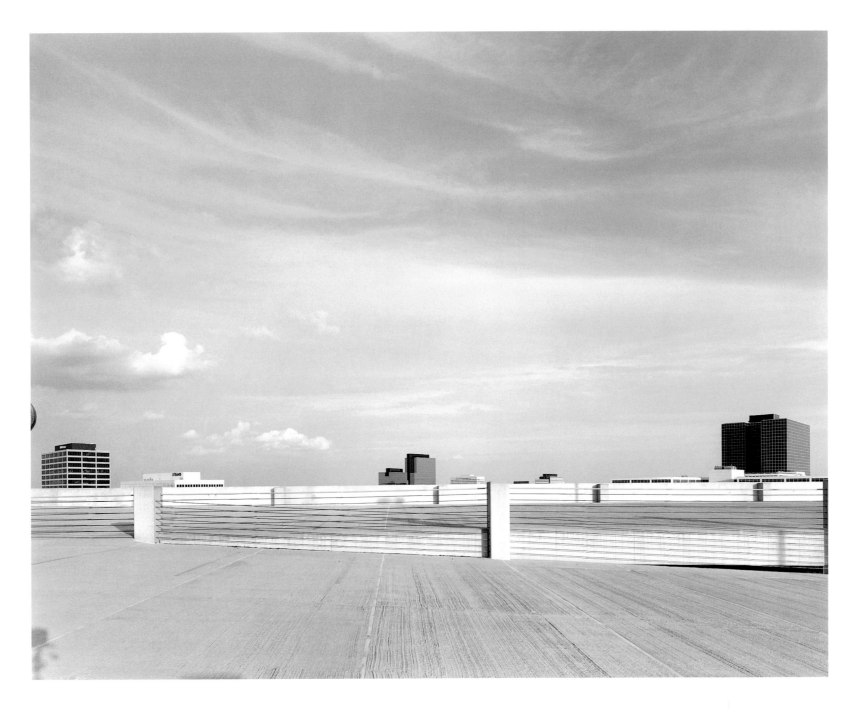

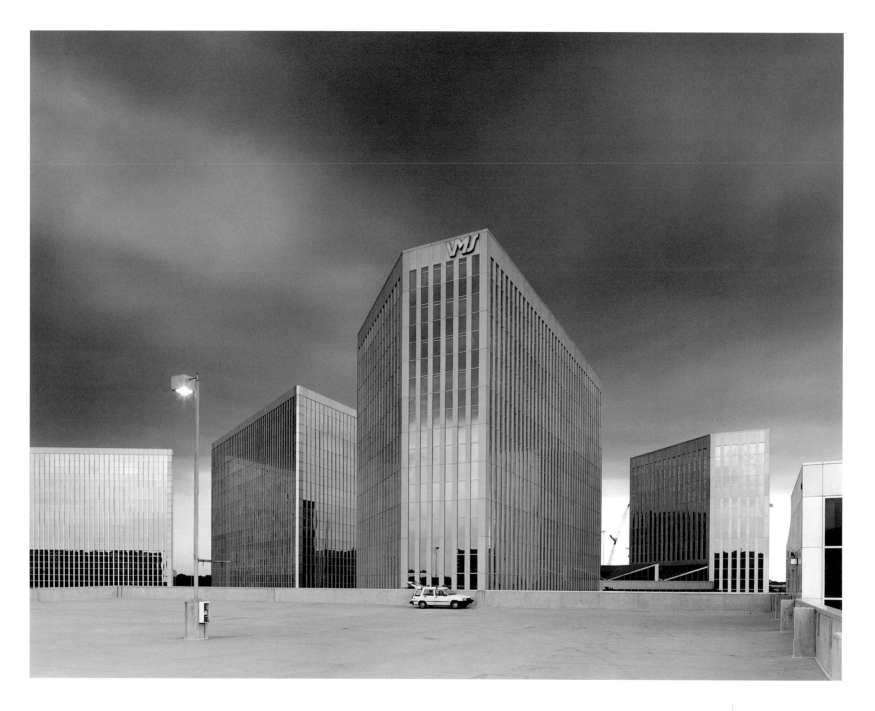

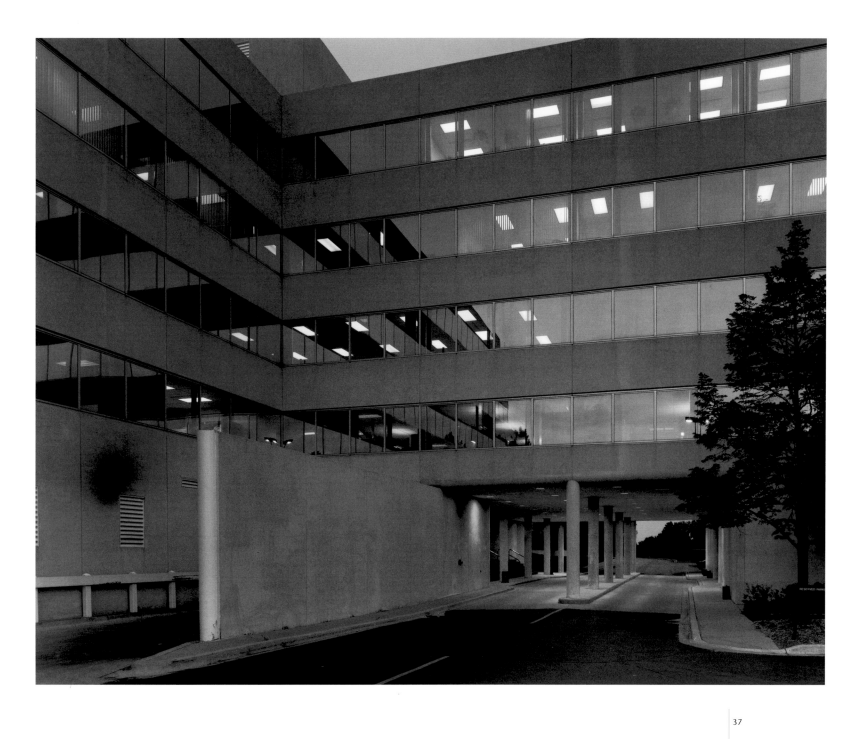

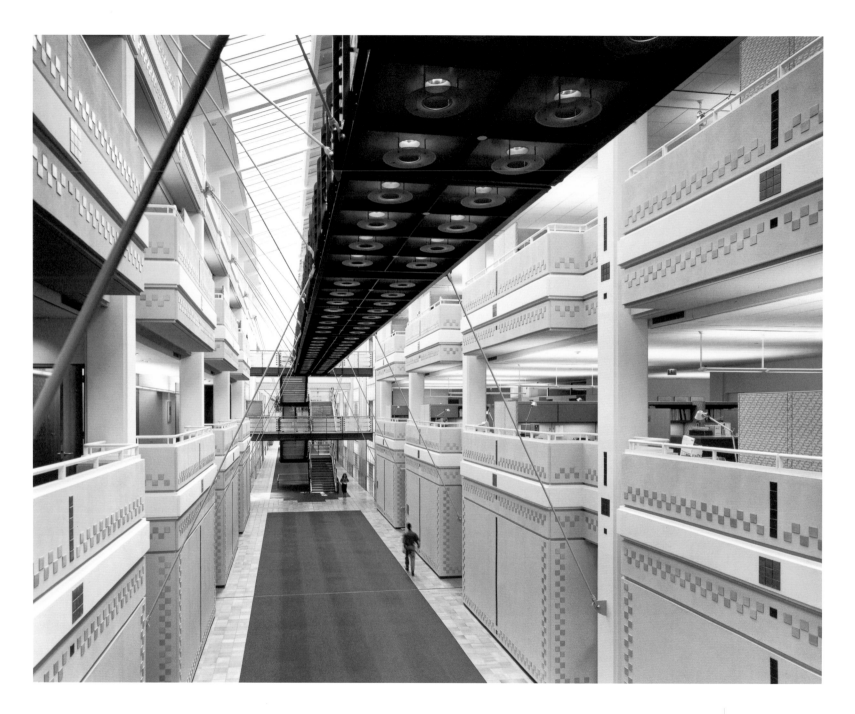

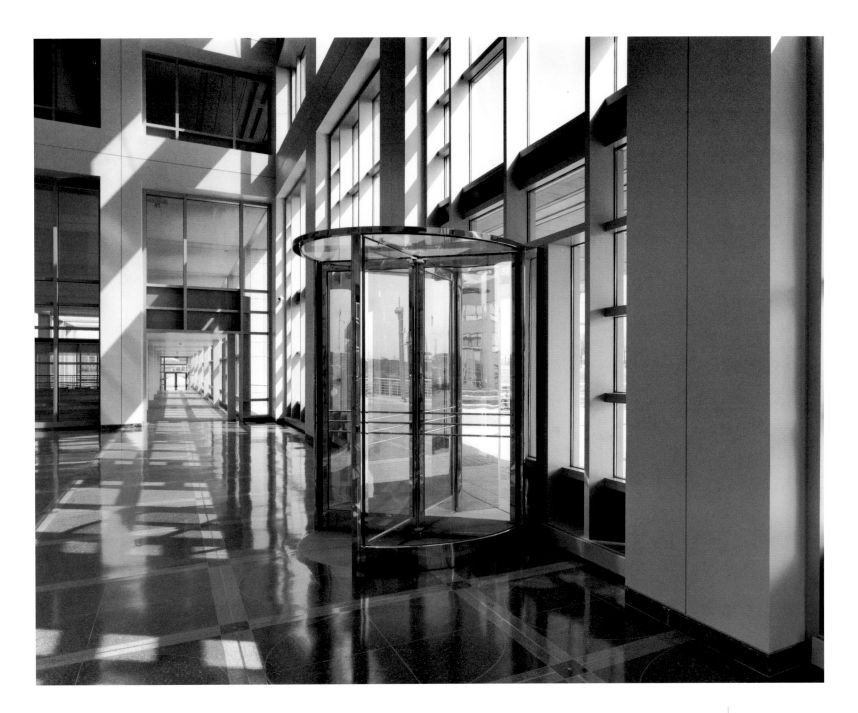

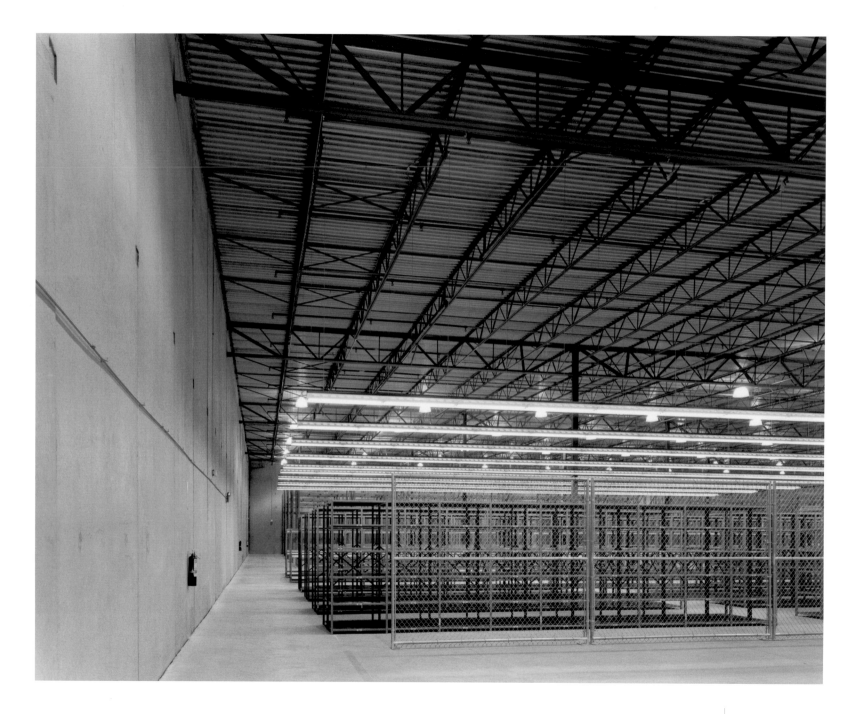

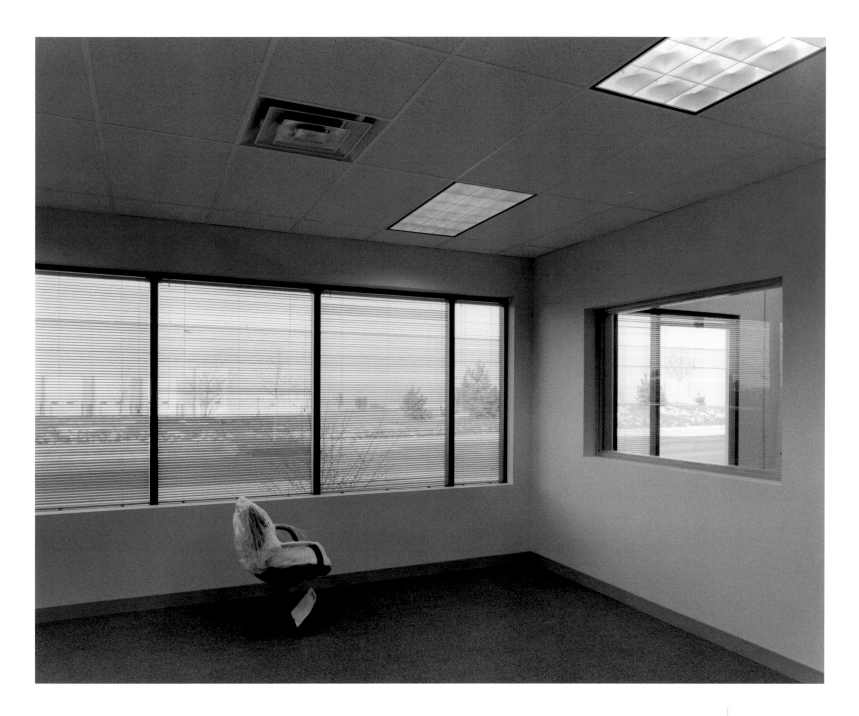

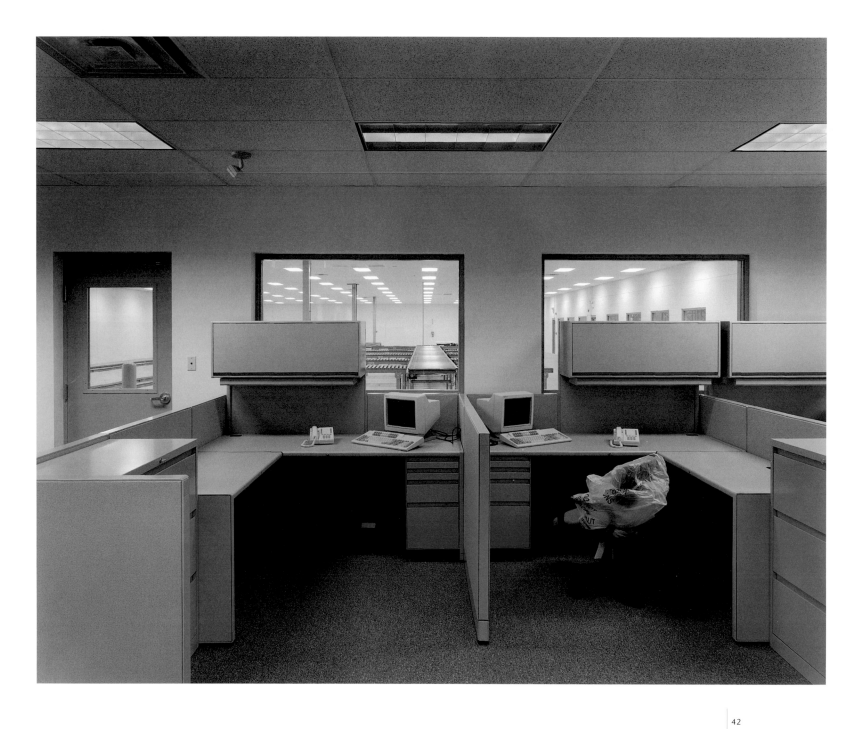

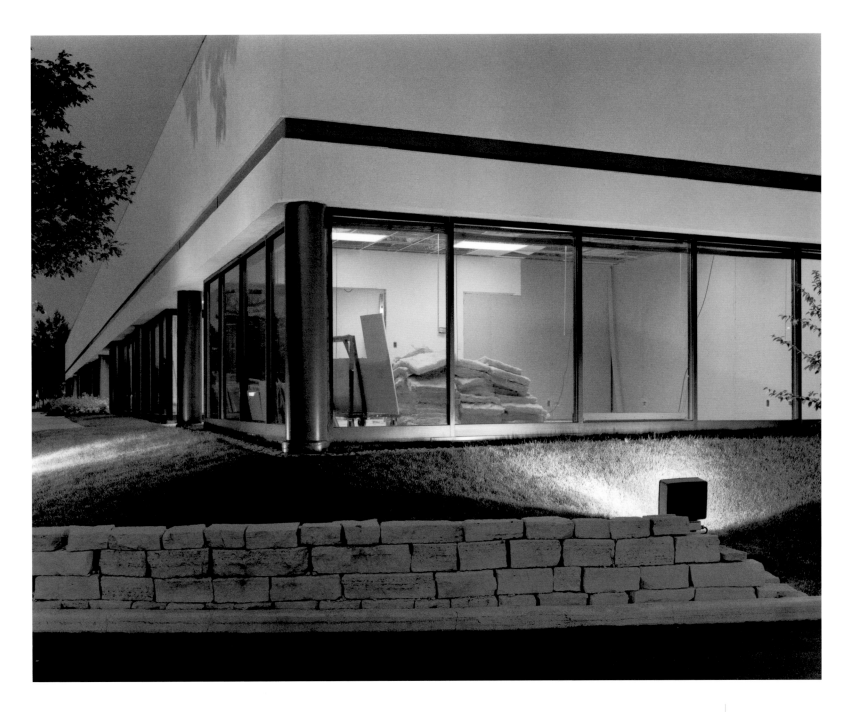

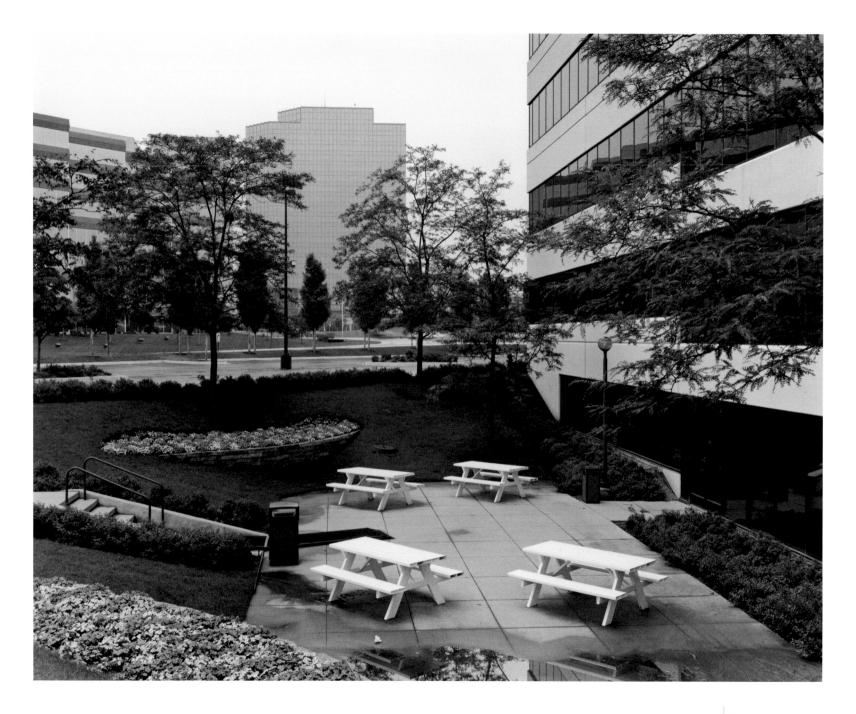

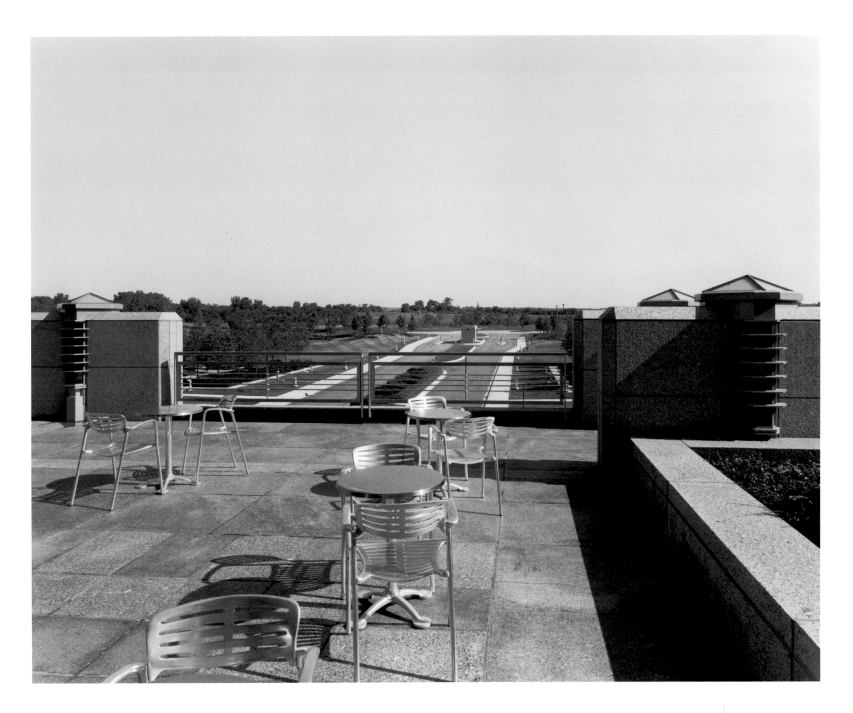

The Commercial Landscape

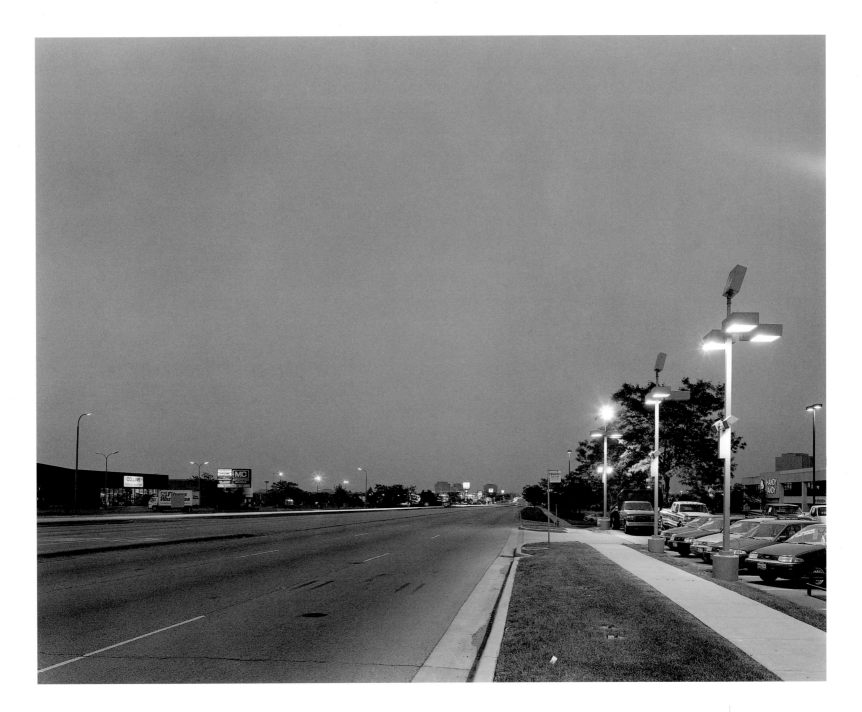

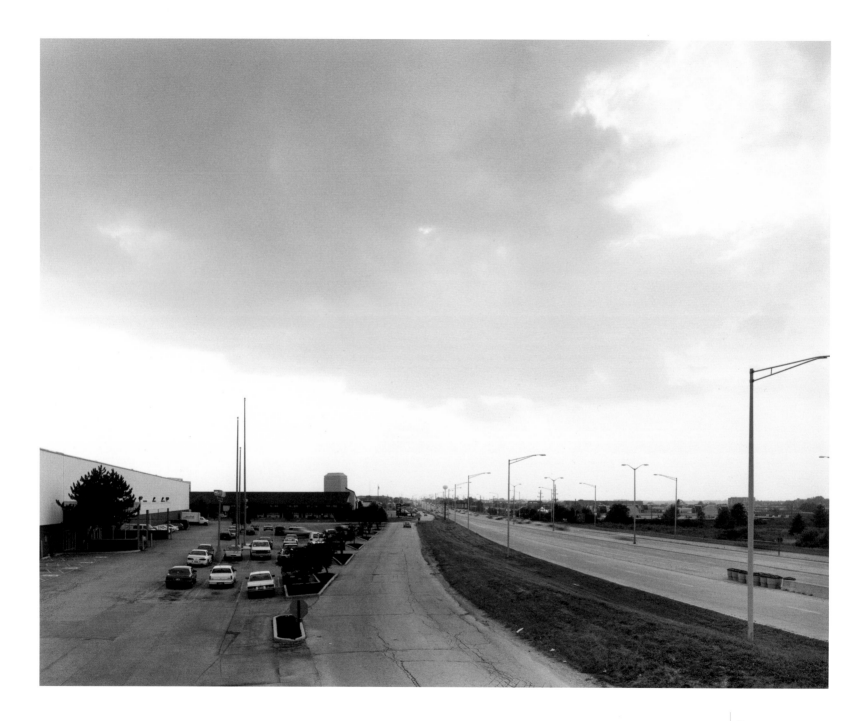

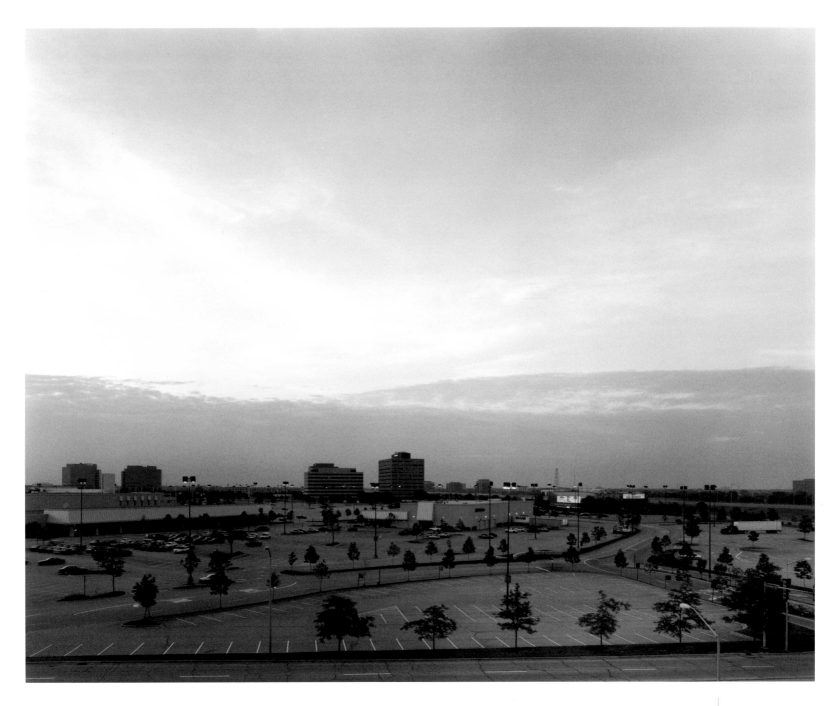

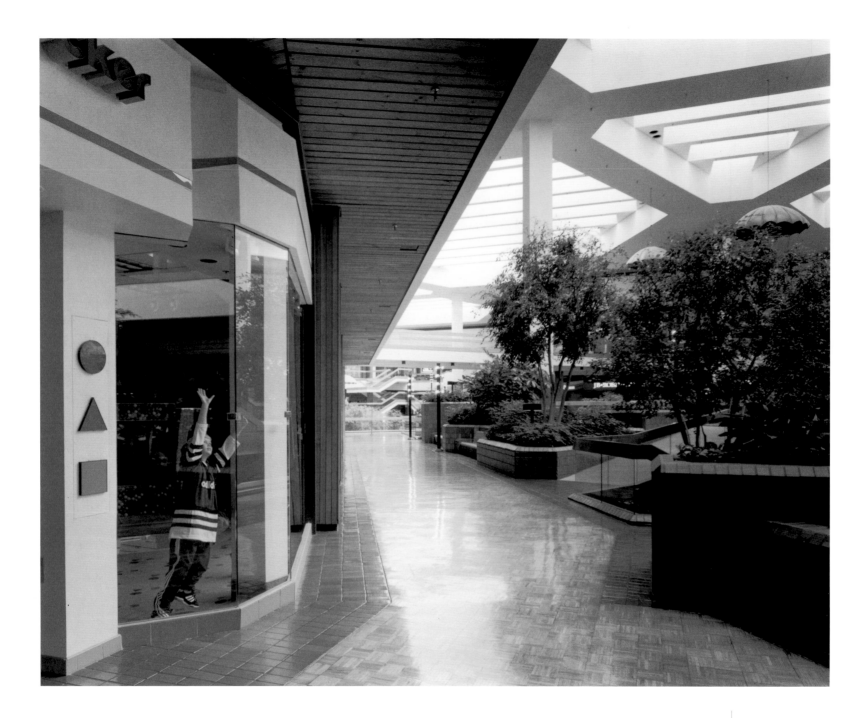

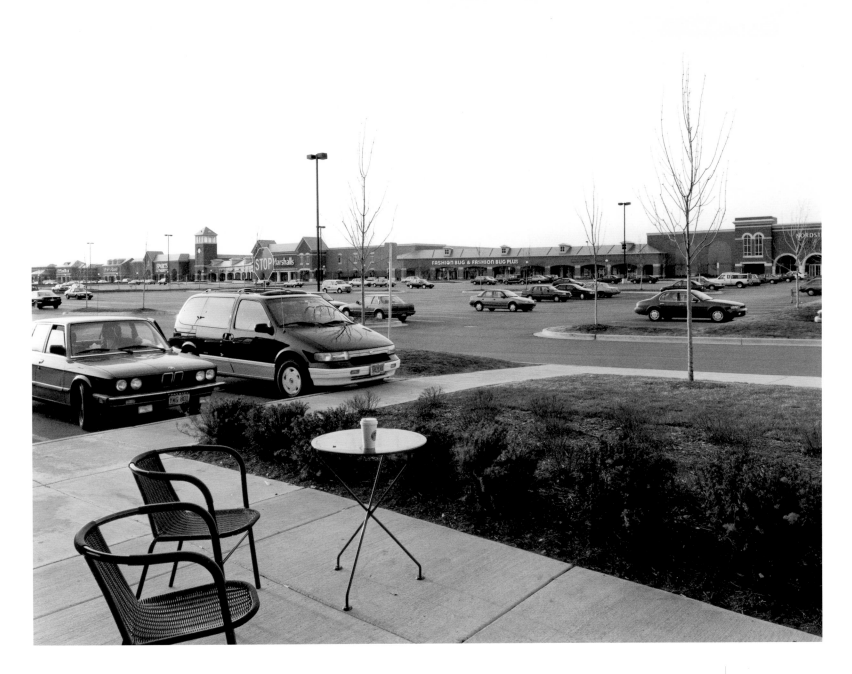

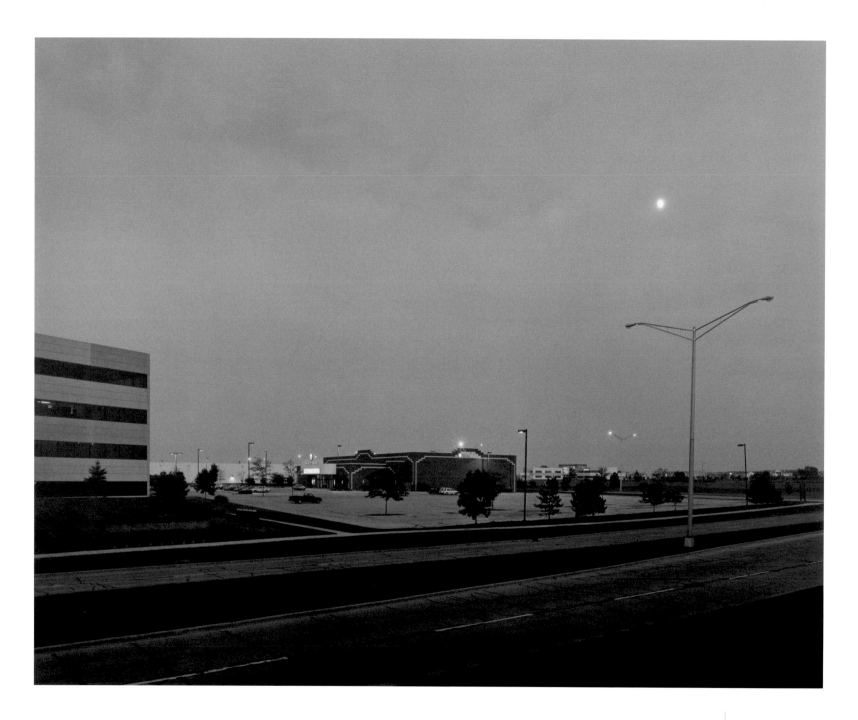

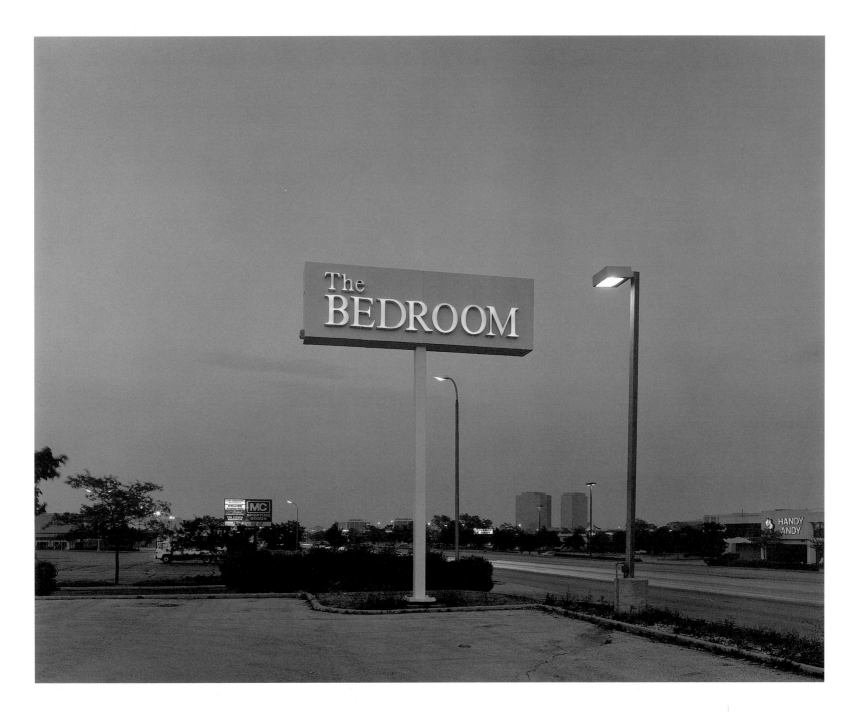

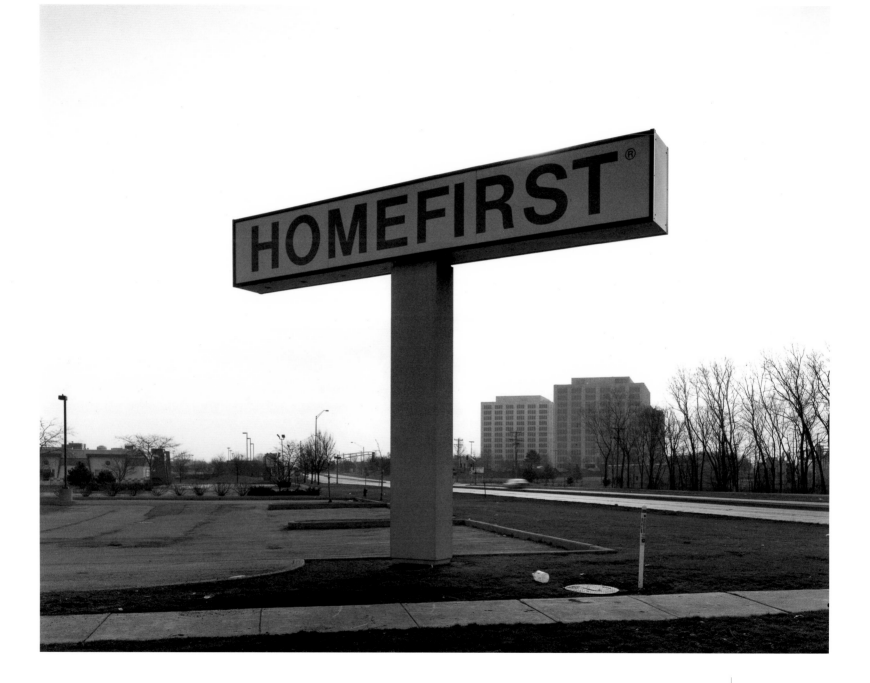

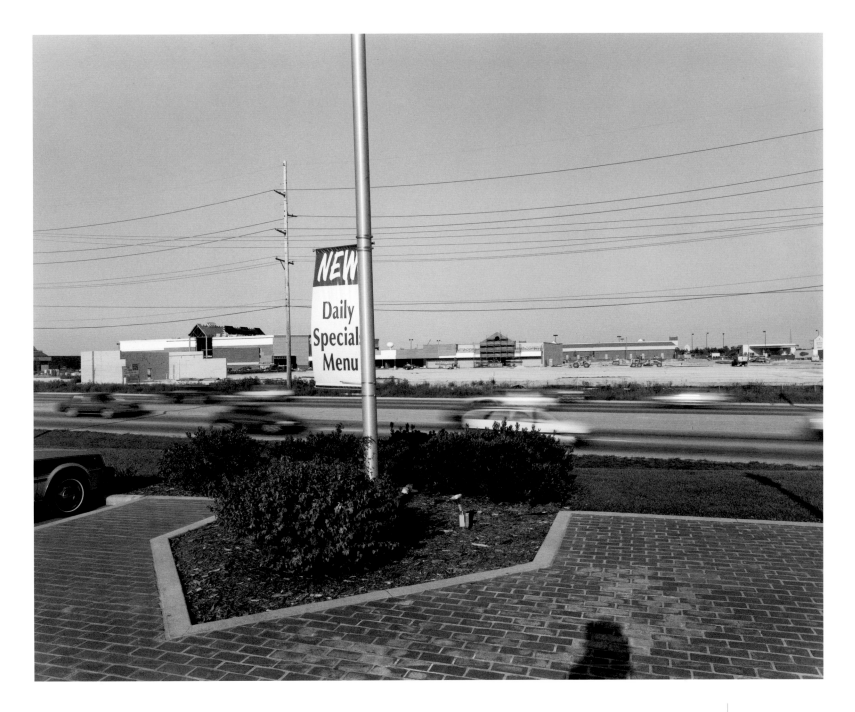

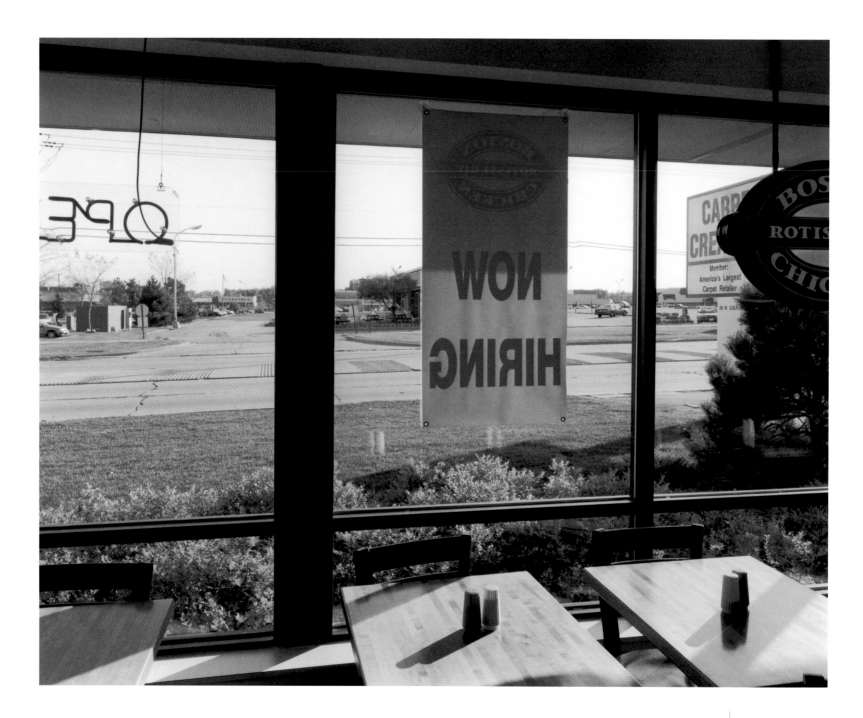

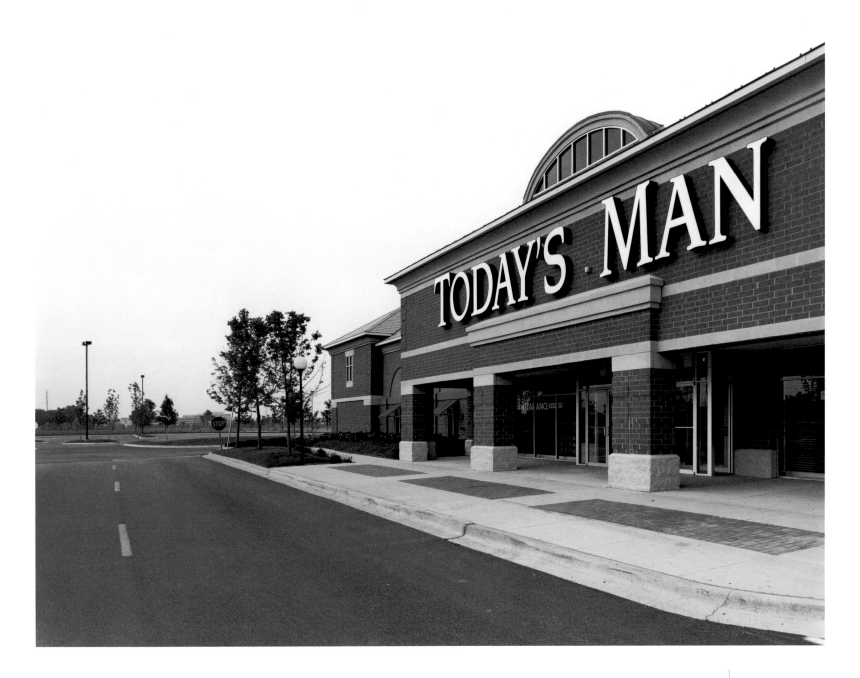

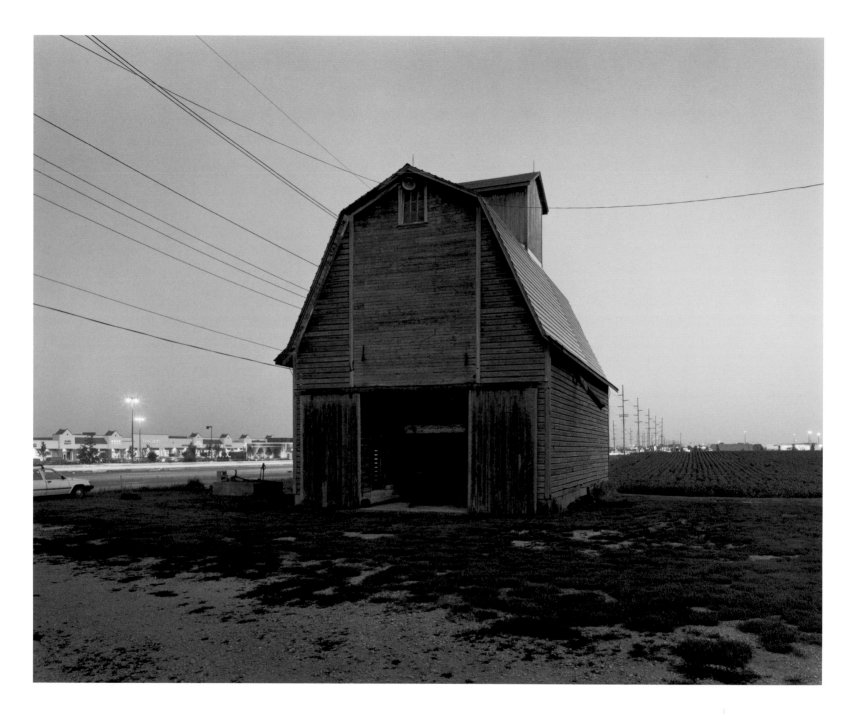

The Domestic Landscape

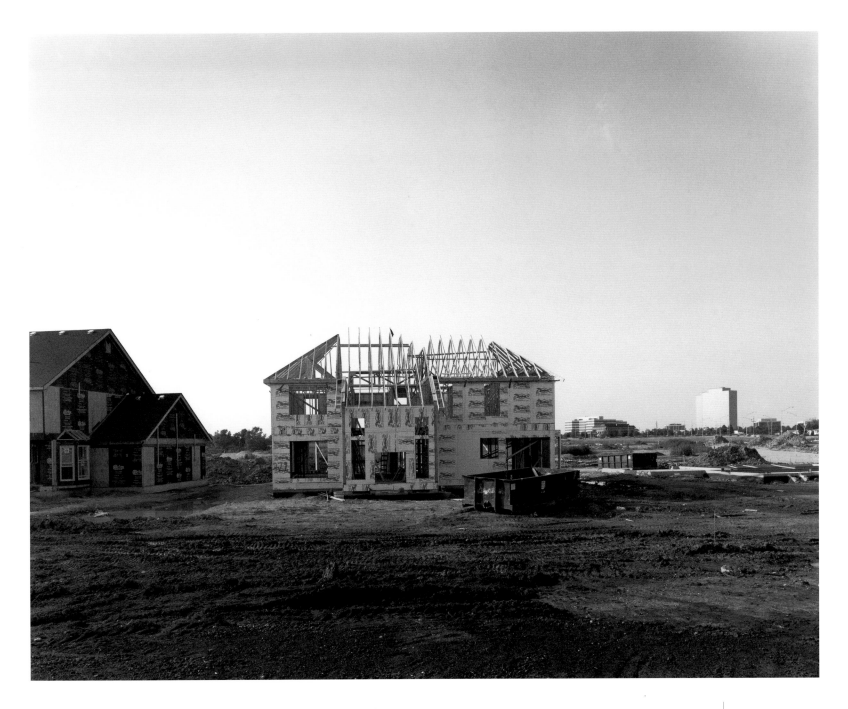

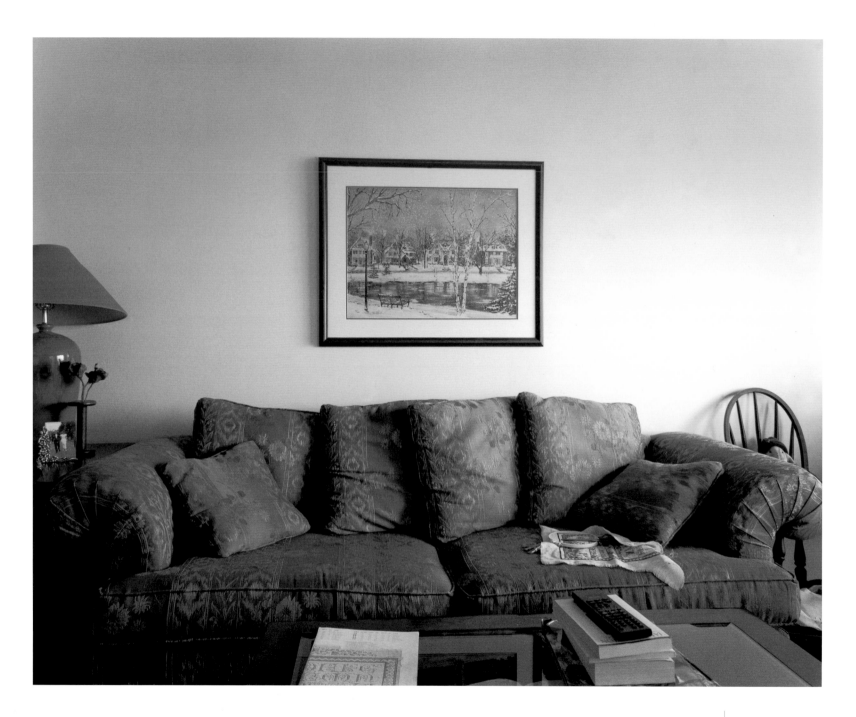

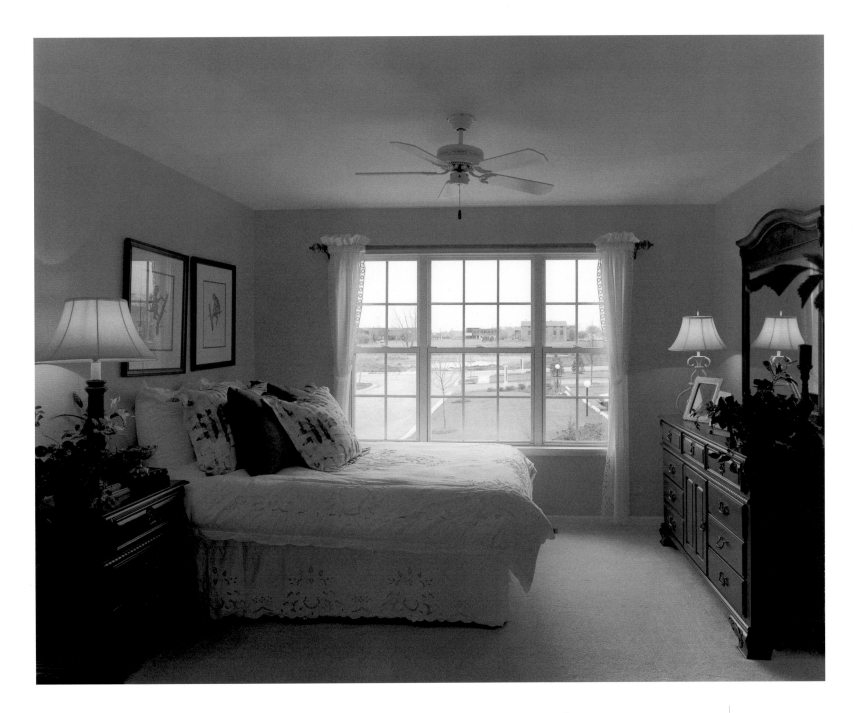

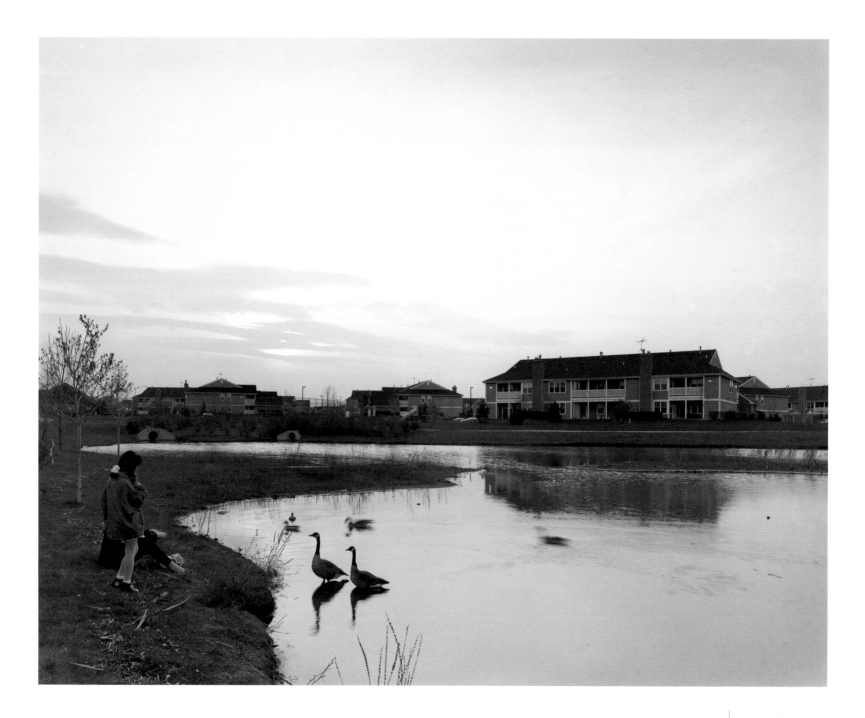

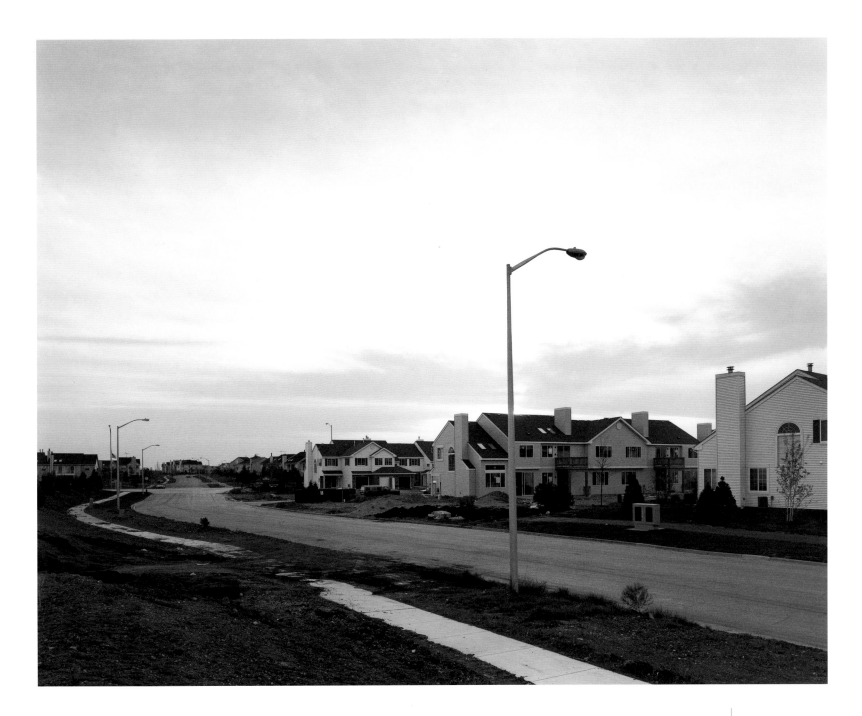

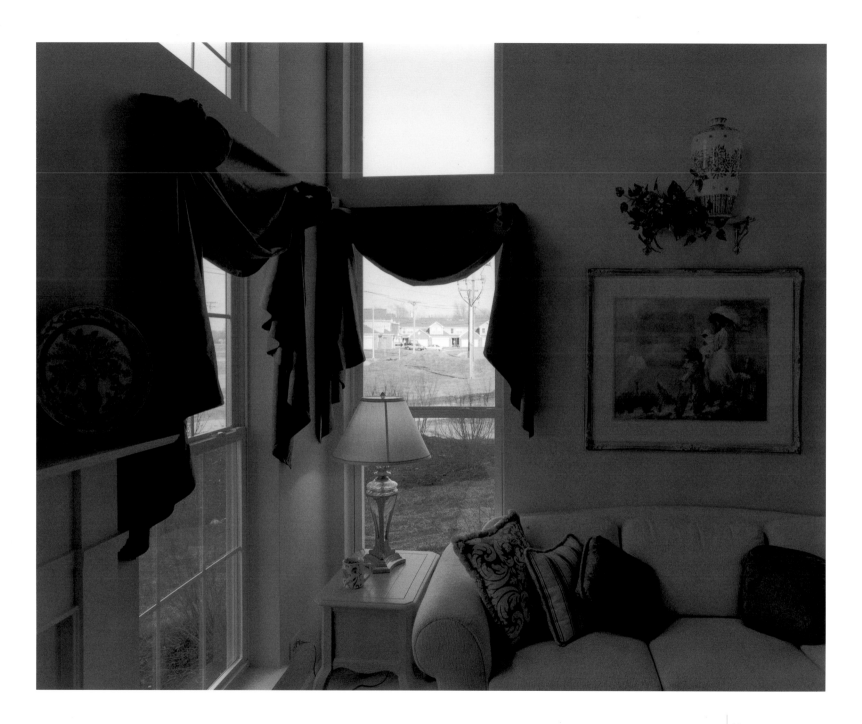

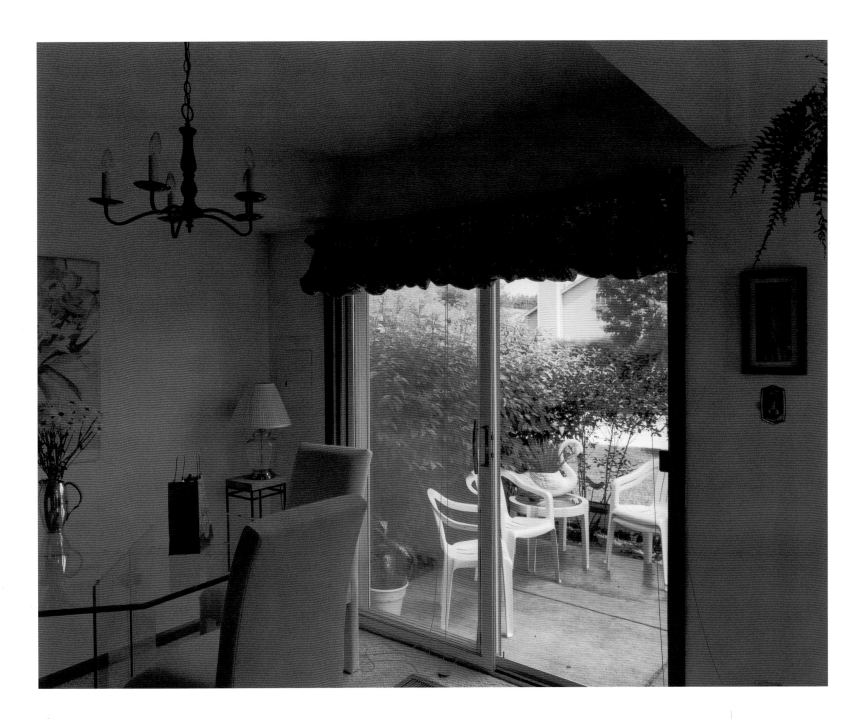

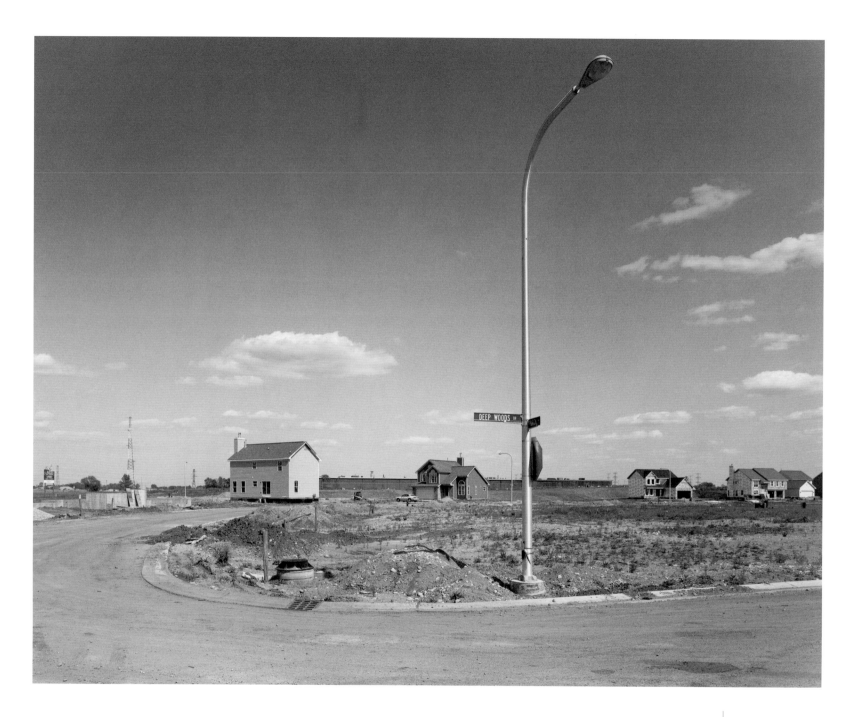

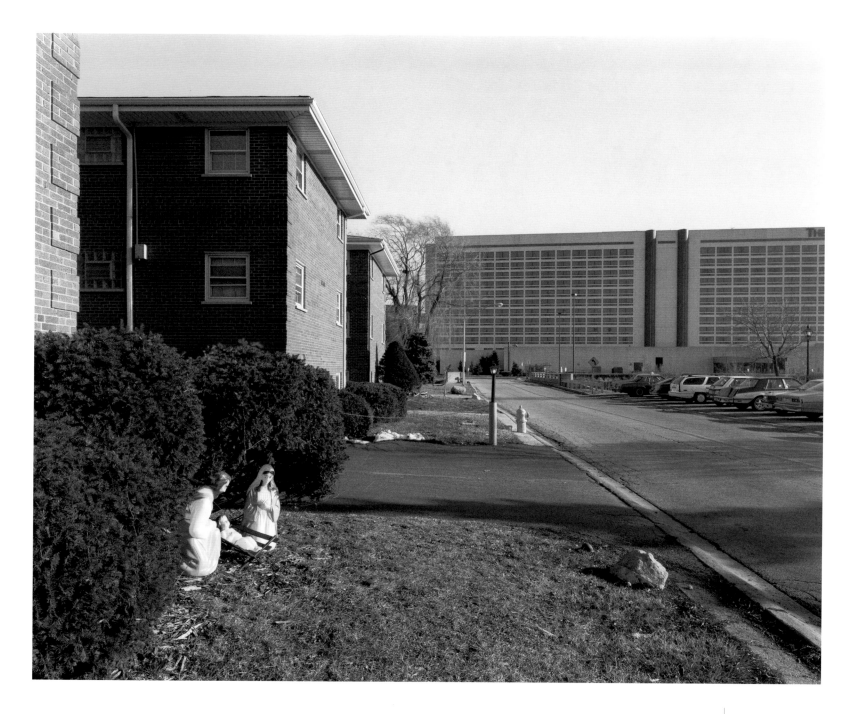

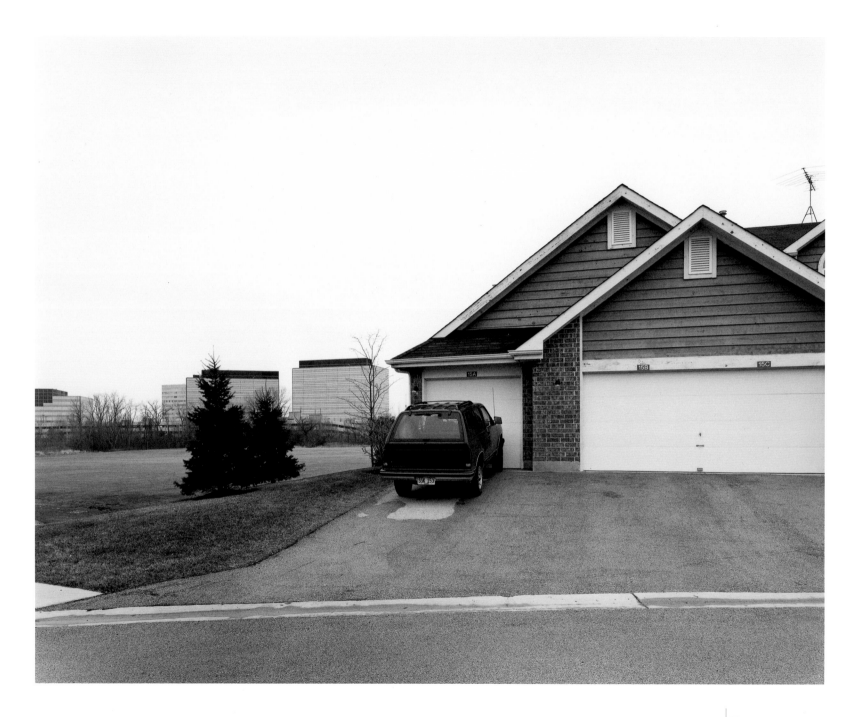

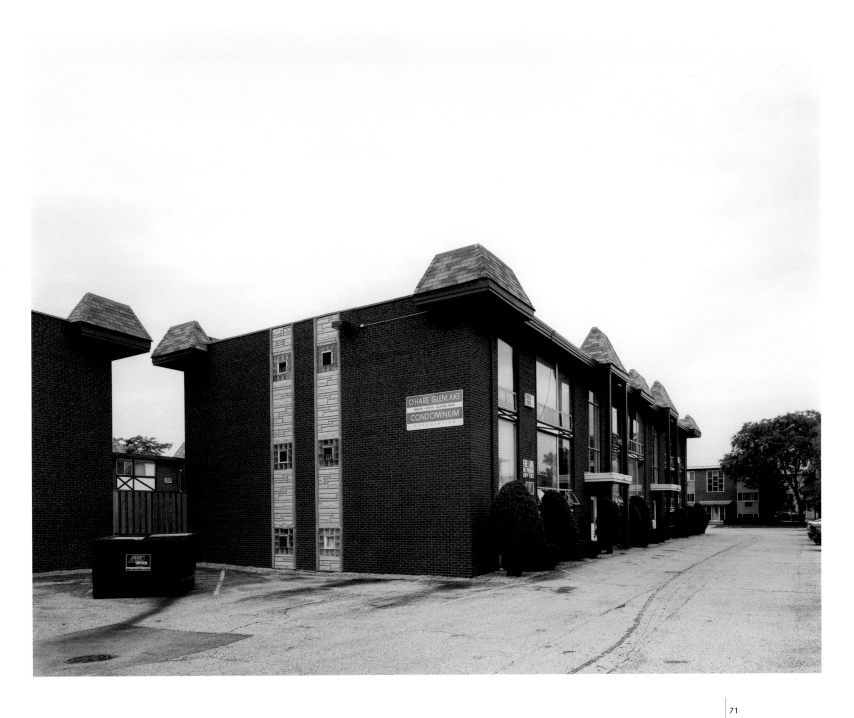

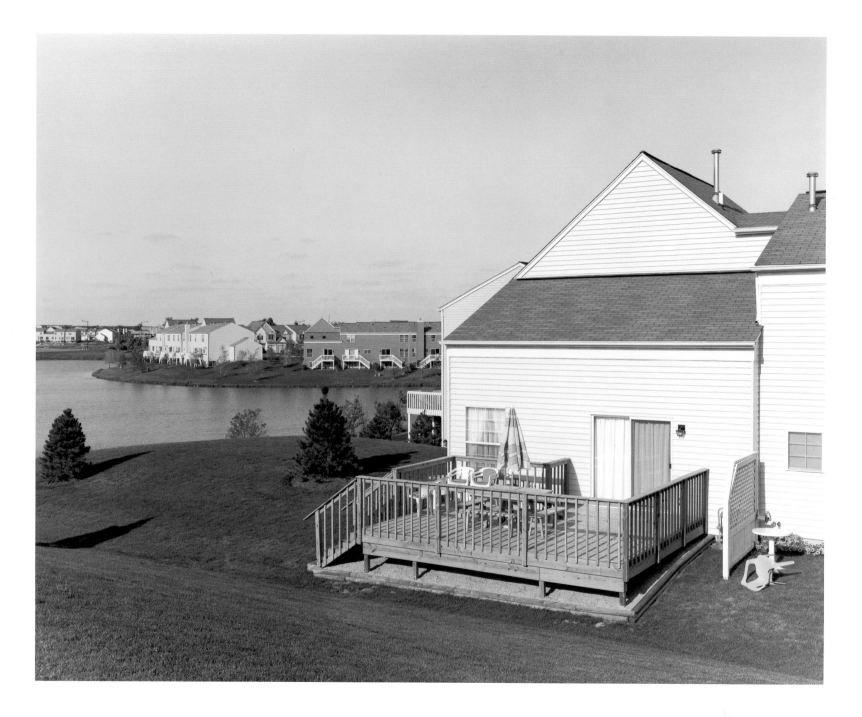

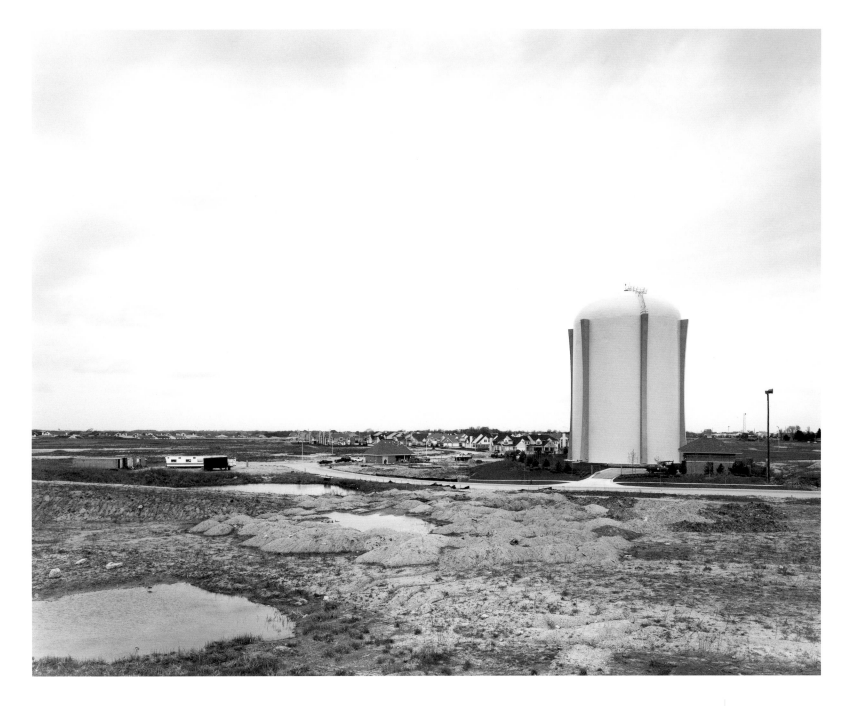

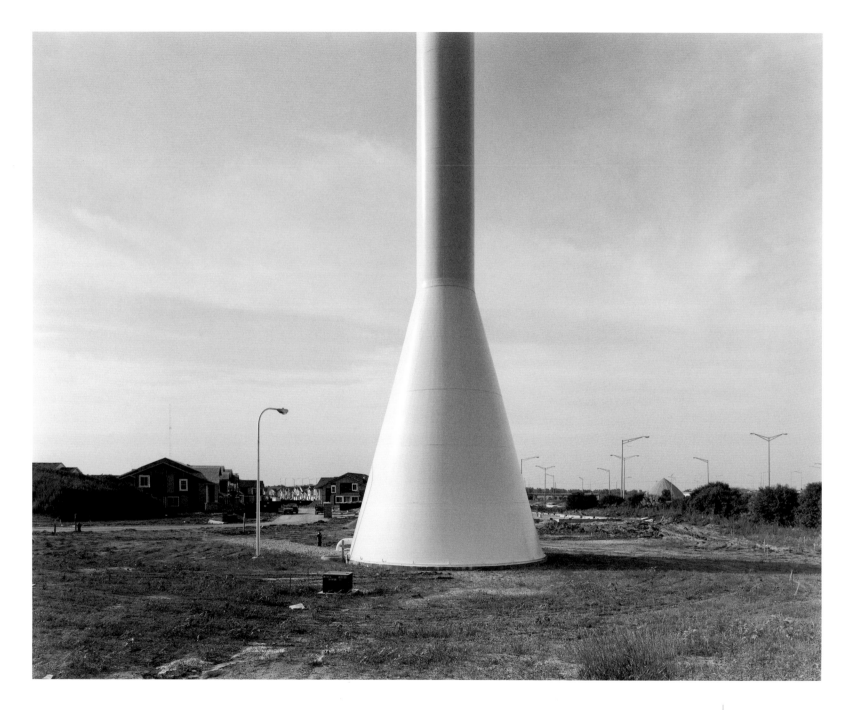

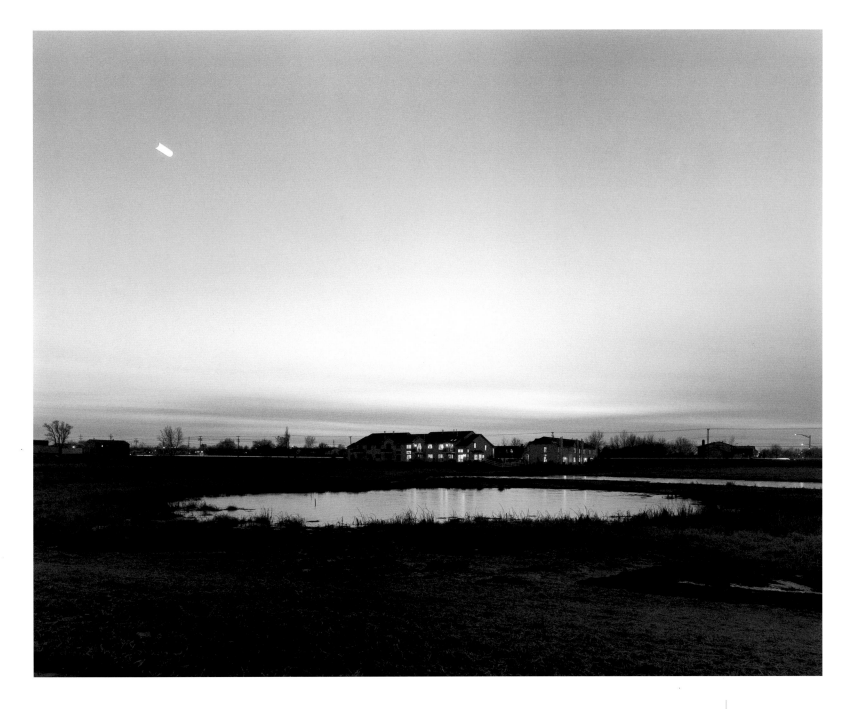

The Landscape of Nature

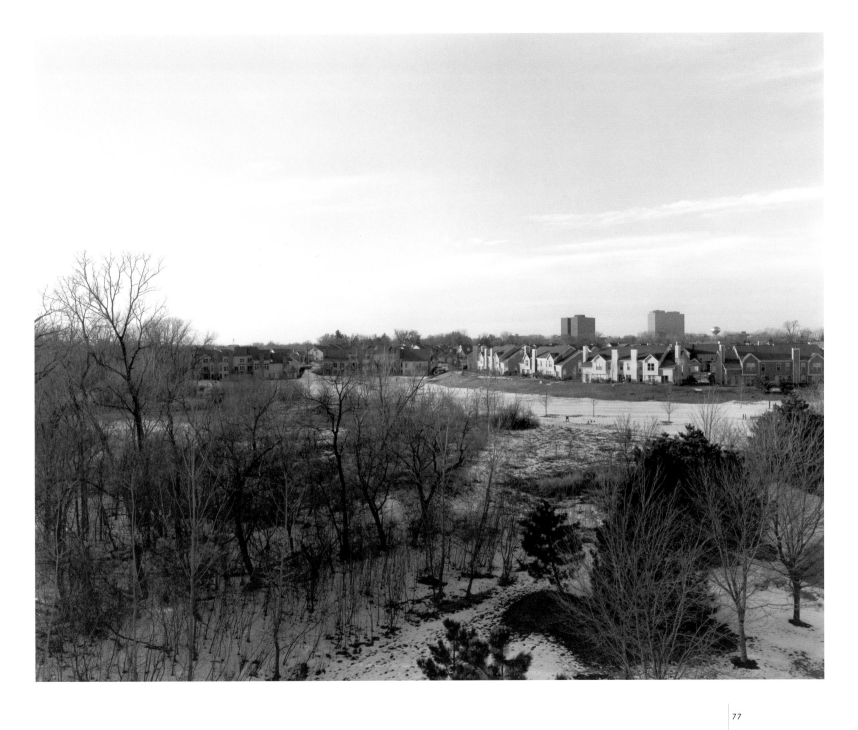

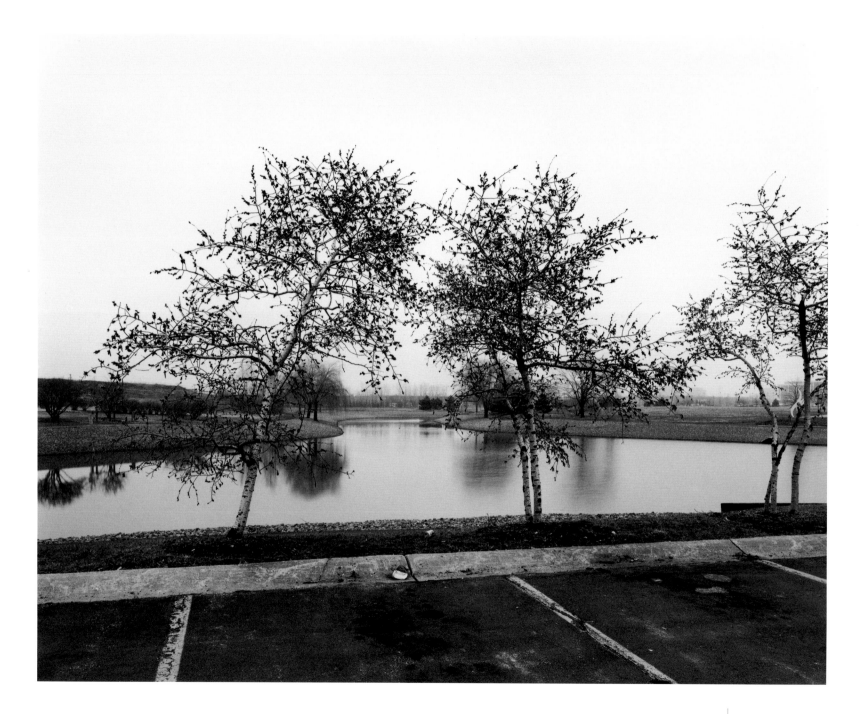

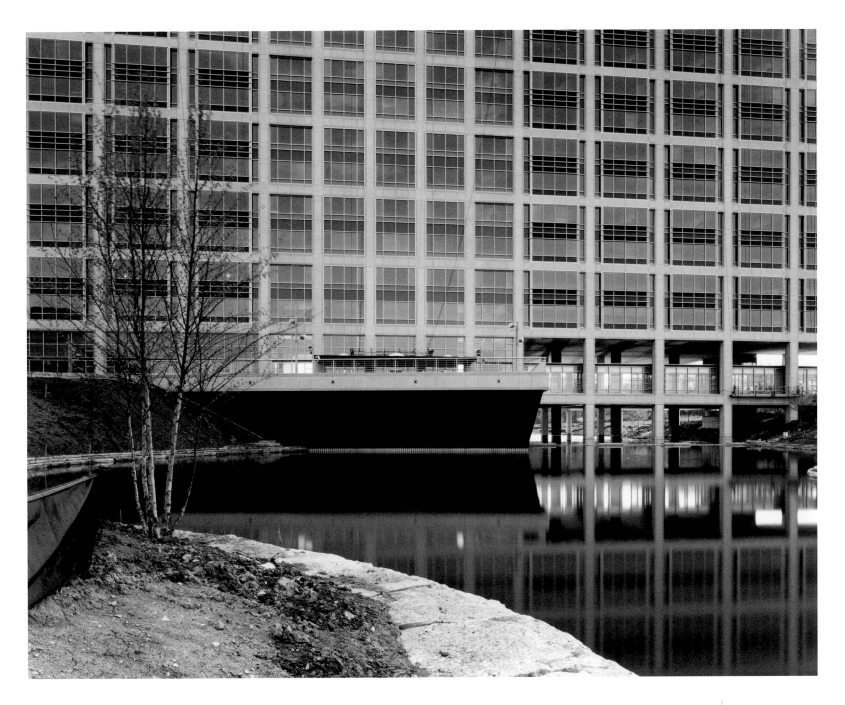

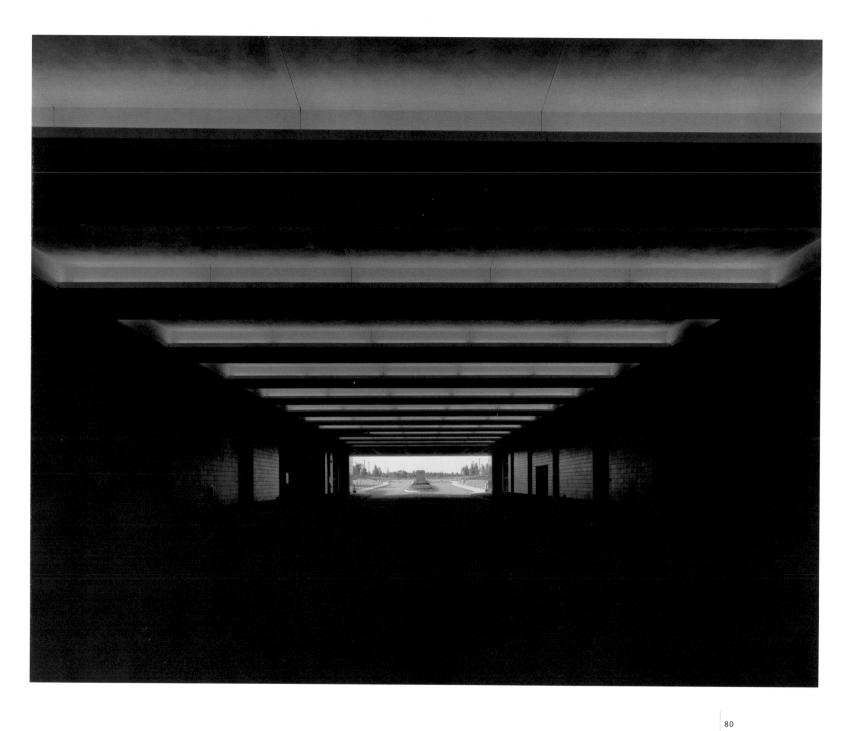

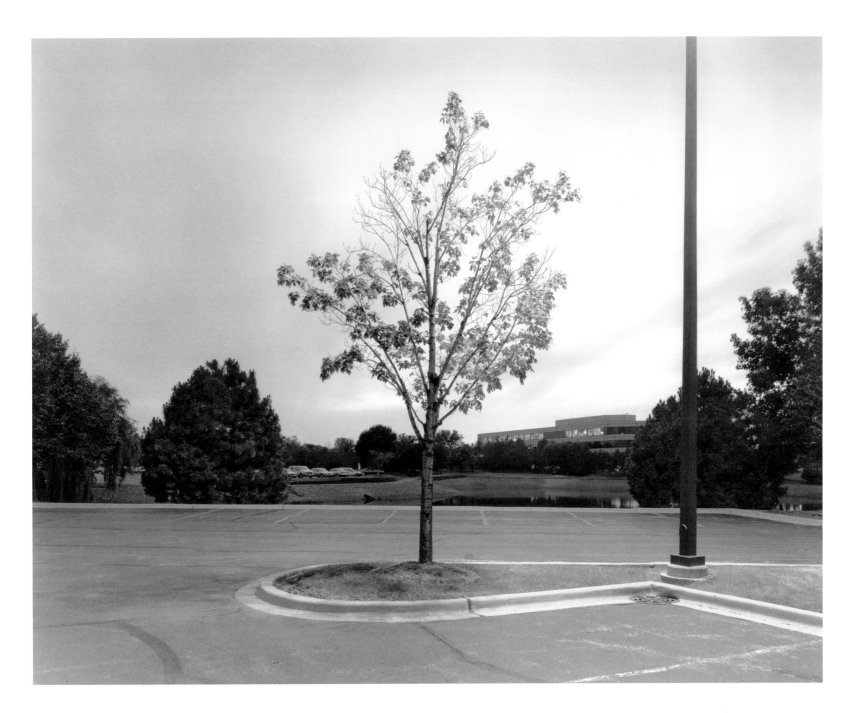

81

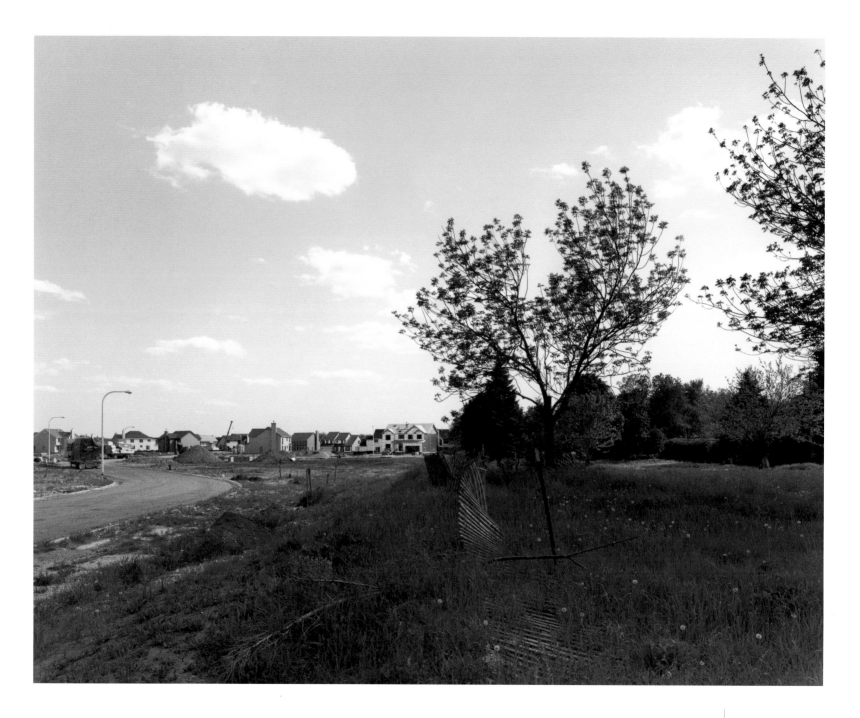

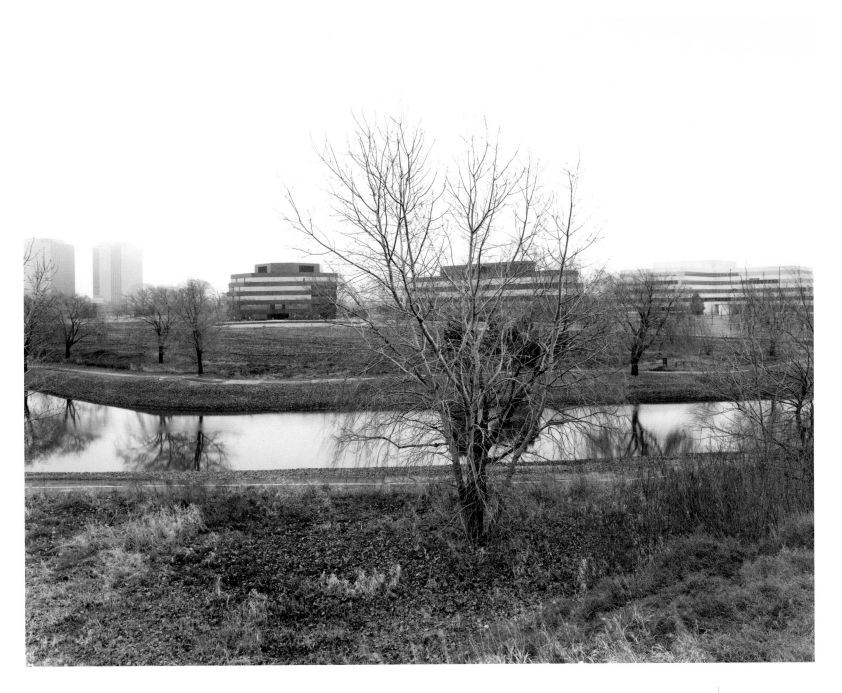

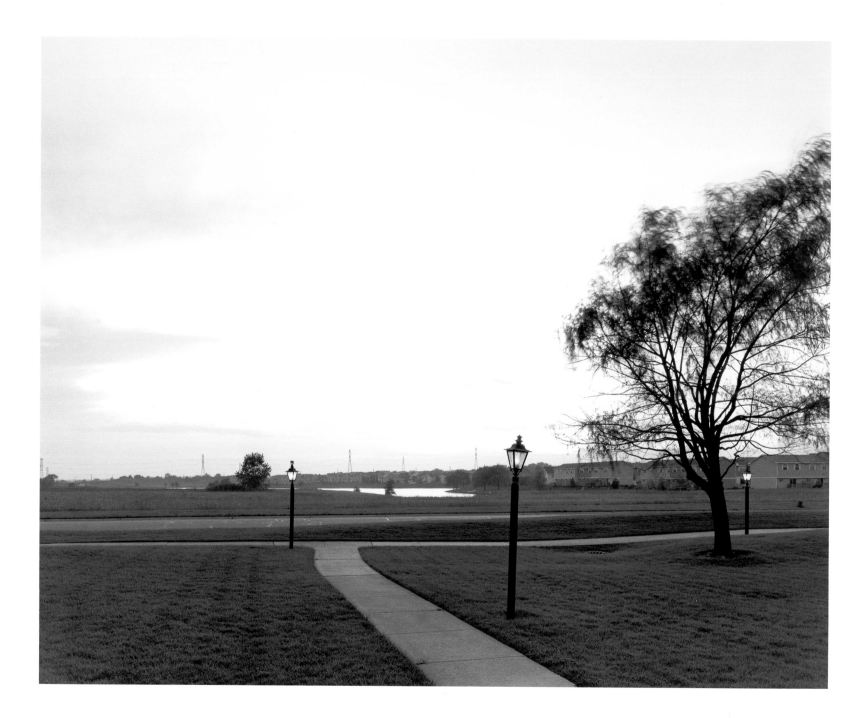

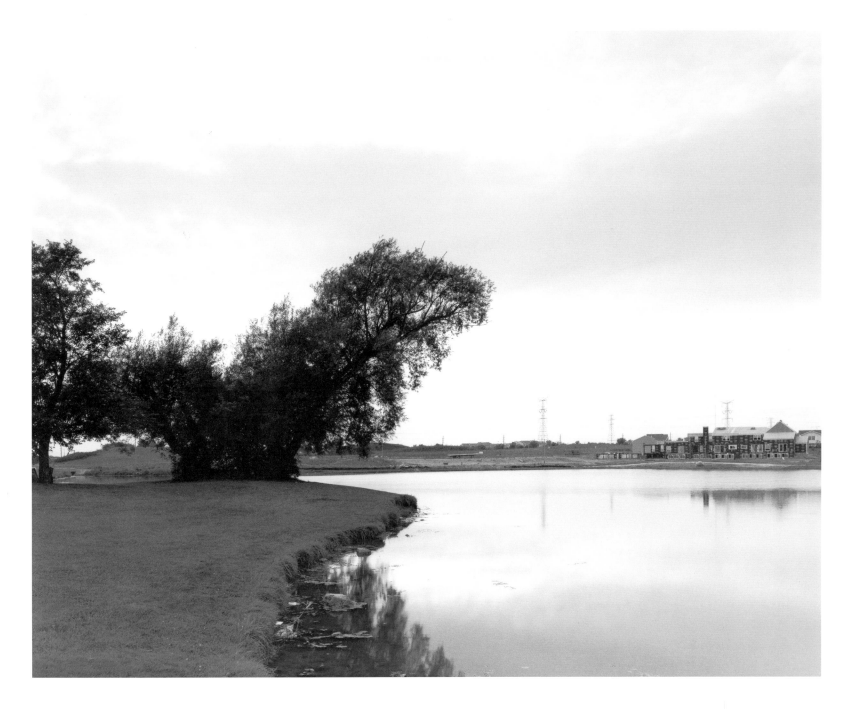

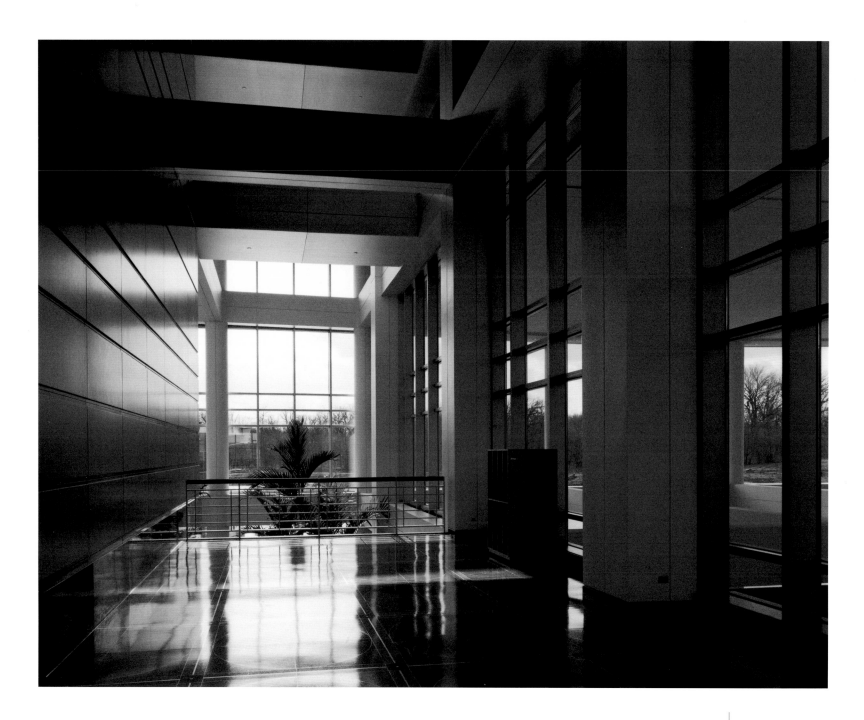

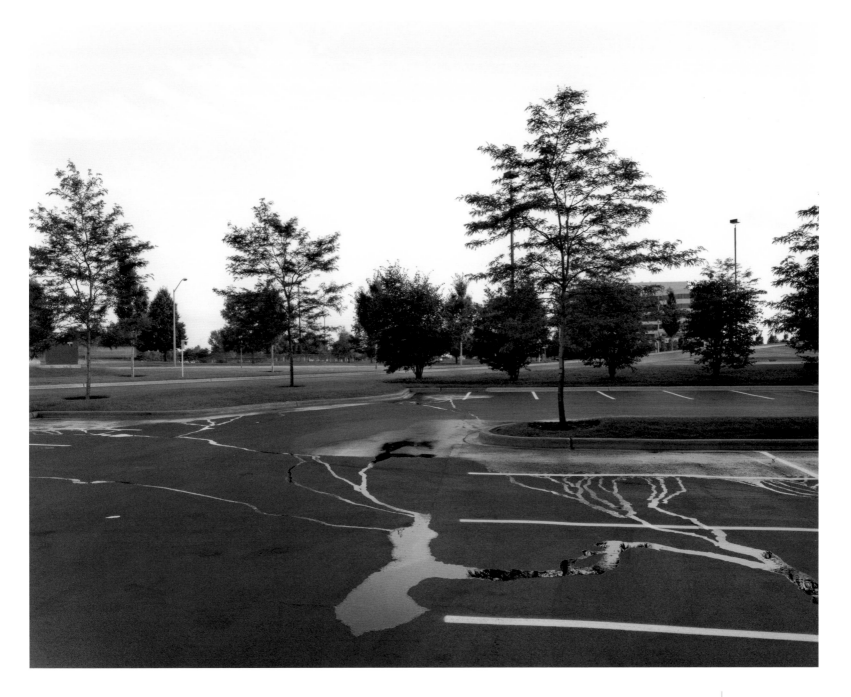

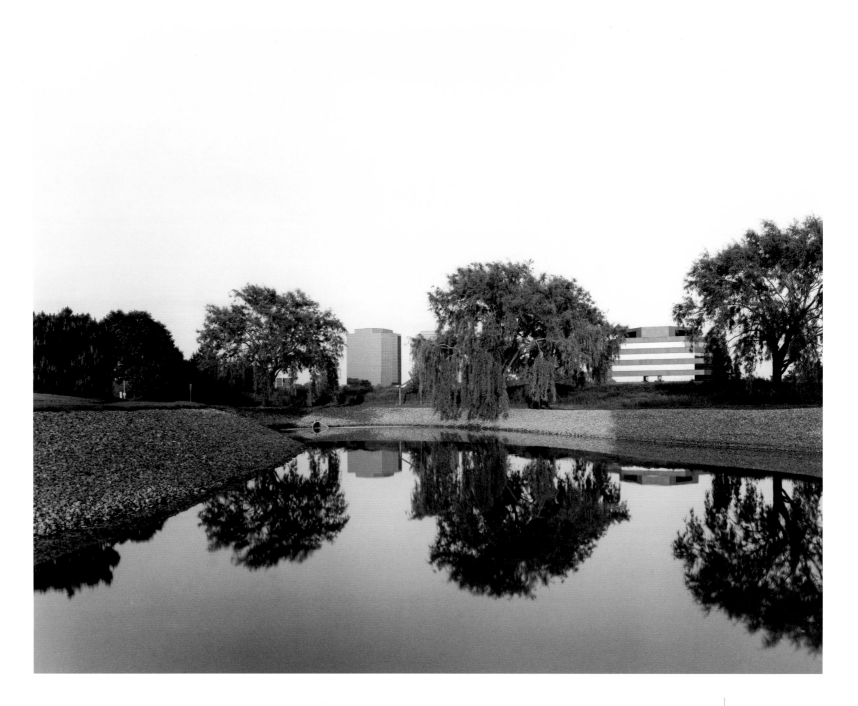

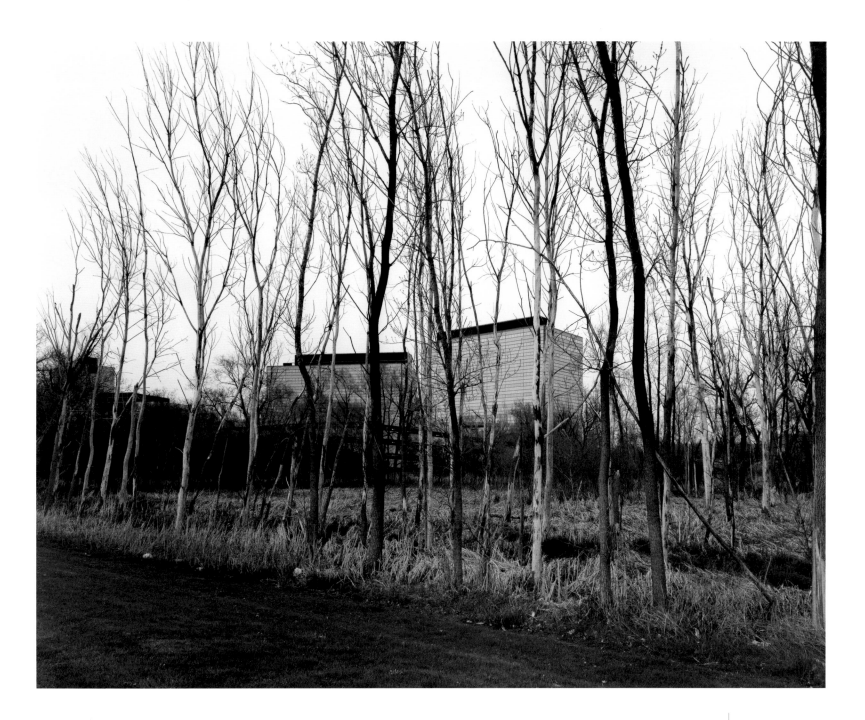

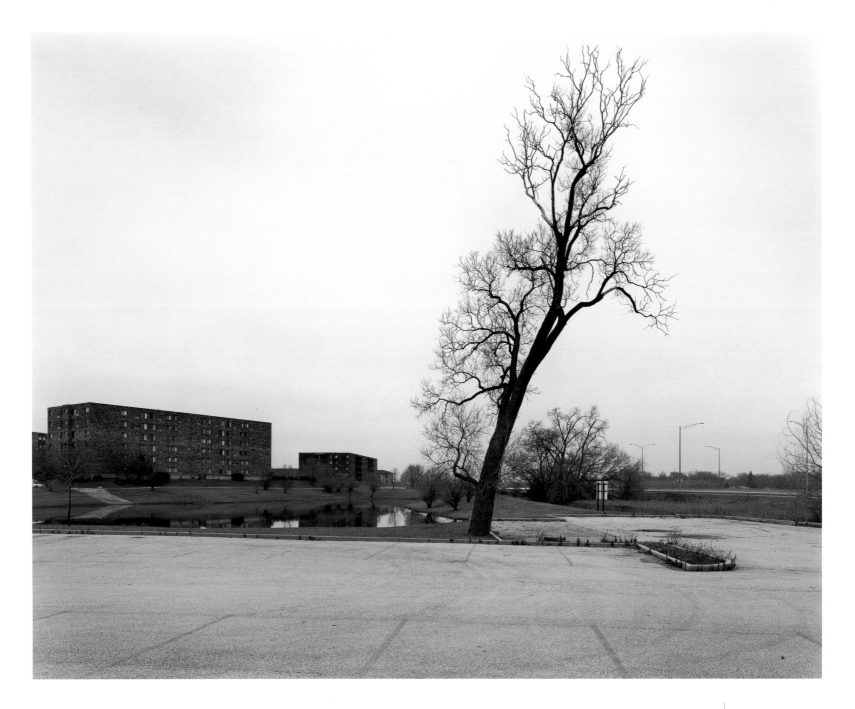

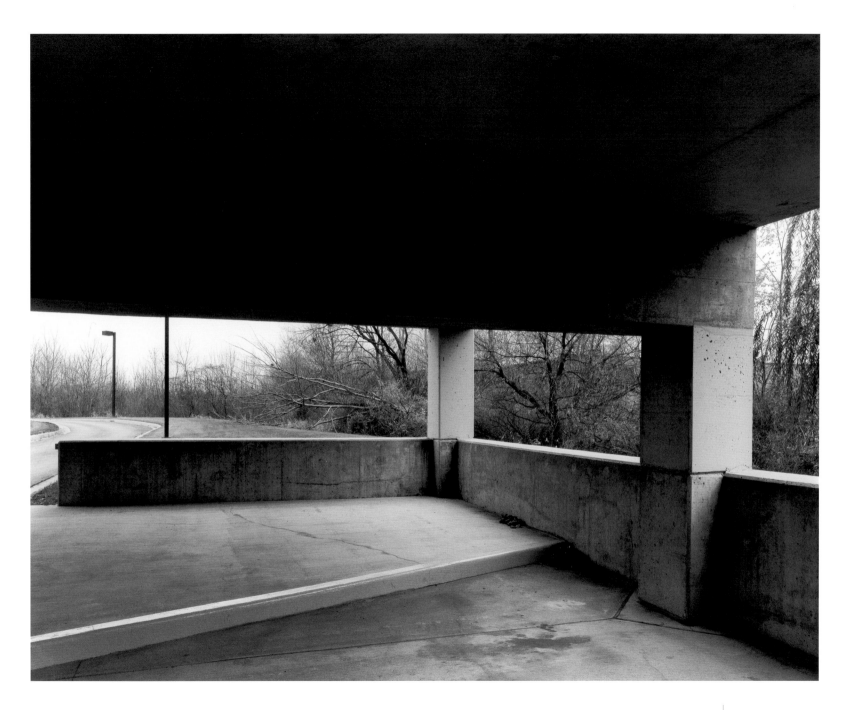

Since I became a serious photographer almost thirty years ago, publishing books of my photographs has been my greatest ambition. I had always imagined that a small book of work done by a single photographer was the result of a solitary, individual effort, much like the making of the photographs. I was wrong. The surprising truth is that even a modest project like this book requires the assistance of a surprising number of generous and talented people. First and foremost I want to thank George F. Thompson, president of the Center for American Places. George has worked with this project from the beginning, encouraging, counseling, and editing. Neither of my books would have been possible without his friendship and incisive assistance.

Denise Miller, Director of the Museum of Contemporary Photography at Columbia College Chicago is known for her ability to put big, complicated projects on track and get them moving like a bullet train. Her help and the involvement of the museum were absolutely essential in completing this book. Columbia College Chicago provided important and generous assistance. I want to thank my friend John Mulvany, chairman of the art and photography departments; Albert C. Gall, executive vice president and provost; and Dr. John B. Duff, president of Columbia College Chicago.

The completion of this book would have been impossible without the generosity of the John Simon Guggenheim Memorial Foundation.

The presentations and publications of the Museum of Contemporary Photography, Columbia College Chicago, are supported in part by grants from the Chicago Community Trust; the John D. and Catherine T. MacArthur Foundation; the Sara Lee Foundation; the Illinois Arts Council, a state agency, and the National Endowment for the Arts; and American Airlines, the official airlines of The Museum of Contemporary Photography. *The New American Village* is especially supported by U.S. Equities Realty, Inc., and grants from the Graham Foundation and the Gaylord and Dorothy Donnelley Foundation.

Gerald Adelmann of Openlands Project, David Travis, and Carol Ehlers provided valuable advice and support.

Many people offered encouragement and thoughtful criticism throughout this project, particularly in the editing and sequencing of these images. I especially want to thank Jocelyn Nevel (who provided advice and moral support from the beginning), John Mulvany, Peter Hales, Alan Cohen, Gregory Conniff, David Harris, Ross Miller, Melissa Pinney, Franz Schulze, Jay Wolke, and my colleagues and students in the photography department at Columbia College Chicago. My colleagues in the digital lab at Columbia College were patient with my muddling computer attempts. I'm grateful to Tom Shirley, Alison McKinzie, Peter Ingraham, and all the teaching assistants. Throughout the project I was happy to know that many of the skillful and perceptive people who worked on *The Perfect City* would contribute to this book, especially Glen Burris. Two excellent young photographers, Travis Roozee and Becky Boehner, assisted me from time to time in the darkroom. Randall B. Jones, at the Center for American Places, and Celestia Ward, at the Johns Hopkins University Press, patiently helped with innumerable details.

Many people and companies in the suburbs were open-minded, friendly, and helpful as I wandered about with my camera and dark cloth. Among those hundreds of people I would like to thank: Ameritech, Amber Dahl, Best Buy, Canon, Liz Borre, Boston Market, Valerie Burke, Cathryn Harding, Karl Heitman, Cheri Petteron, Pam Schawel, Spiegel, and of course, Paul Cecchini.

BOB THALL was born and raised in Chicago, and he received his B.A. and M.F.A. degrees in photography at the University of Illinois, Chicago. In 1976 he joined the faculty of Columbia College Chicago where he is now Columbia College Professor of Photography. Mr. Thall was a principal photographer on the National Road and Court House projects, and in 1998 he was awarded a John Simon Guggenheim Memorial Foundation Fellowship for Photography. His photographs are in the permanent collections of the Art Institute of Chicago, the Canadian Centre for Architecture in Montreal, the Getty Center for the History of Art and the Humanities, the International Museum of Photography, the Library of Congress, the Museum of Fine Art in Houston, and the Museum of Modern Art in New York City, among others. He is the author of *The Perfect City* (Johns Hopkins University Press, 1994), which was accompanied by a one-person show at the Art Institute of Chicago.

THE NEW AMERICAN VILLAGE

by Bob Thall

Designed by Glen Burris, set by the designer in Fenice, Stone
Sans, and Stone Serif, and separated and printed on 157gsm
Japanese matte art by C & C Offset Printing Company, Inc.

Library of Congress Cataloging-in-Publication Data

Thall, Bob.

 The new American village / Bob Thall.

 p. cm. — (Creating the North American landscape)

 Includes bibliographical references.

 ISBN 0-8018-6157-8 (alk. paper). — ISBN 0-8018-6158-6 (pbk.:

alk. paper)

 1. Chicago Region (Ill.)—Pictorial works. 2. Landscape—

Illinois—Chicago Region—Pictorial works. 3. Suburban life—

Illinois—Chicago Region—Pictorial works. I. Title. II. Series.

F548.37.T48 1999

977.3'11—dc21 98-49379 CIP